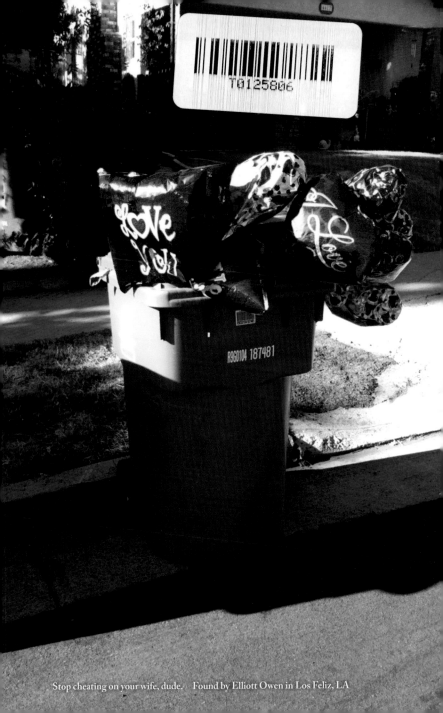

T0125806

R9G0104 187481

Stop cheating on your wife, dude. Found by Elliott Owen in Los Feliz, LA

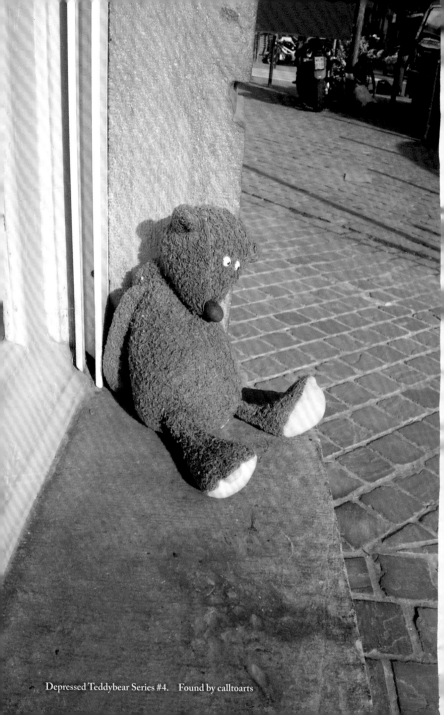

Depressed Teddybear Series #4. Found by calltoarts

Sad Stuff on The Street

Sloane Crosley and Greg Larson

With Contributions By

Michael Chabon
Jesse Eisenberg
Ben Gibbard
Miranda July
Lin-Manuel Miranda
Todd Oldham
Salman Rushdie
Amy Sedaris

AMMO

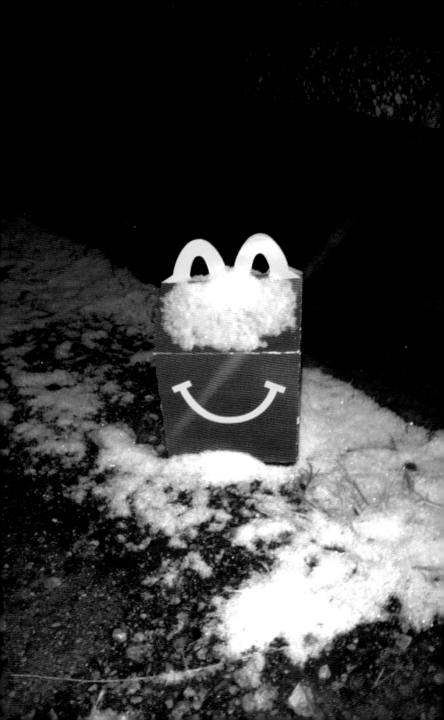

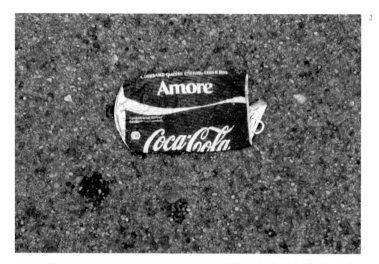

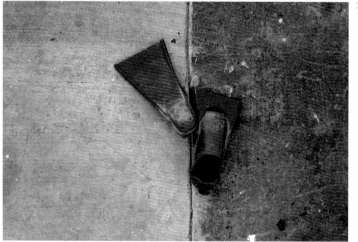

1	*2*	*3*
Sad Happy Meal.	Crushed love.	Urban scuba.
Found by whitneypeck	Found by TwoGoonies	Found by Baby Harriet
in Chicago, IL	in Italy	in New York, NY

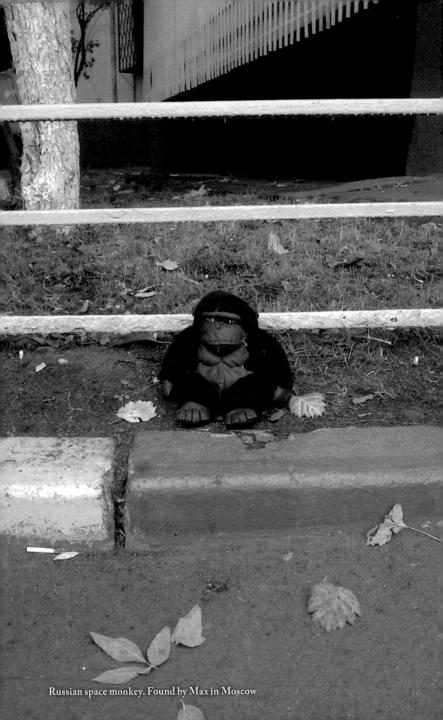

Russian space monkey. Found by Max in Moscow

Introduction

In the beginning, things were happy. Hairbrushes, balloons, loafers, bread loaves, Bobby pins, Sponge Bobs—all the inanimate objects of the world were going about the business of being worn and wheeled and generally serving their purpose. Until, one day, they weren't. Either intentionally or by chance, they became detritus of the streets, left out in the rain or the sun but left either way. If they had vanished, like socks in the dryer, at least they would have retained some mystery. Some dignity. Instead, they were exposed and alone and not particularly mourned. And just like that, things were sad. It's not so much that they were abandoned, though that's also depressing, but that their stories were left untold. Until you.

For seven years, we have maintained a blog called *Sad Stuff on The Street*. Founded in an earlier era, before Instagram or Snapchat, the blog is more or less what it sounds like. Every day, strangers from around the globe send us photos of the sad things they spot on the street and we provide (sometimes literal, sometimes mildly clever) captions. We started it as a joke because we are easily amused people who get our kicks from disemcottoned Teddy Bears. But over the past seven years, we've noticed that something transformative happens to these objects when photographed. They morph from sad to funny. They're funny because they're sad. We so wish there was a word for the exact emotion they inspire. Perhaps something French or German that suggests very recent nostalgia or points to the poignant core of life's fleeting nature. Alas, there isn't. We've looked. But if you've ever noticed an object on the street, nodded and thought "aww, how'd you get there, buddy?" you get it.

We are so grateful to the thousands of *Sad Stuff on The Street* contributors for giving these objects a second life, a second purpose. For turning them into art and allowing us to re-share them with the world.

And we would have kept on being grateful and diligently uploading photos, but unfortunately not all sadness is amusing or ironic. It can be deep and devastating and, in America especially, tragic in its stigmatization and preventability. Our blog has nothing to do with mental health, but we have long wanted to support the mental health cause. Which is why we are donating 100% of the proceeds from this book to NAMI, The National Alliance on Mental Illness. To be frank, mental illness is a tough cause to raise money for because it's not direct. It's not a sudden natural disaster but a slow private one. You cannot select the wing of sanity you'd like your money to go to. You cannot film it. You cannot give it clean water. You can't even take a picture of it. Which brings us back to this book.

Above Spontaneous healing. Found by sailing-by-night in Seattle, WA
Right I've had enough of your chatter. Found by Emily O'Brien in Boulder, CO

In addition to our global army of sad stuff spotters, we have solicited the help of iconic designer Todd Oldham as well as a handful of artists, actors, advocates, musicians and writers we admire. Plus, for your viewing pleasure, we have selected the very best of *Sad Stuff on The Street*. We hope this book—while making people laugh in a French or German manner— can also raise some money for this incredibly important cause. We also hope that the submissions keep rolling in. When it comes to Sad Stuff on The Street, it's best to keep your head down. And when it comes to mental health, it's best to keep your head up. This life is all about that mix, that nod.

— *Sloane and Greg*

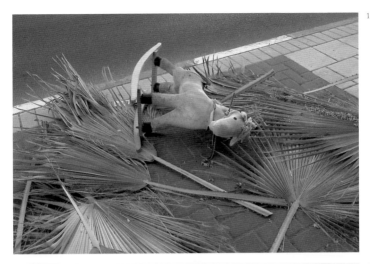

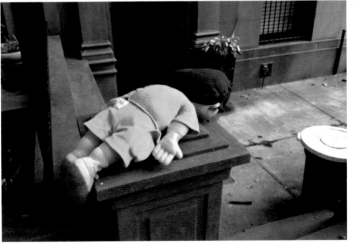

1	*2*	*3*
Pony wanted	Playing dead.	Just a doll.
a palm-frond burial.	Found by Jacqueline Tse	Found by Jaackie
Found by shartiella	in Brooklyn, NY	

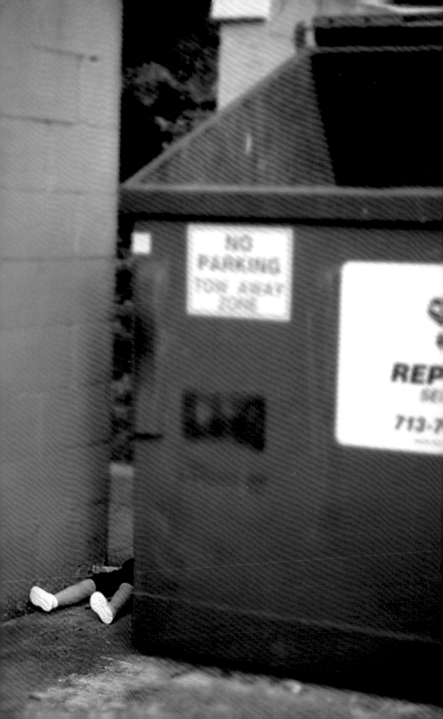

Amy Sedaris

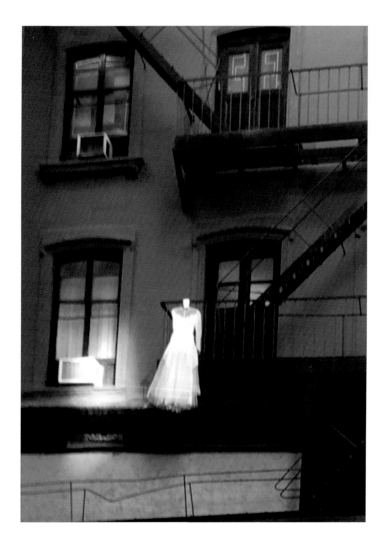

Veils from the Crypt.
Found by Amy Sedaris

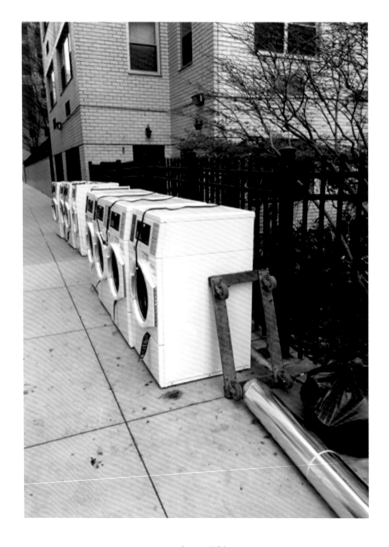

Airing life's
dirty laundry.
Found by Amy Sedaris

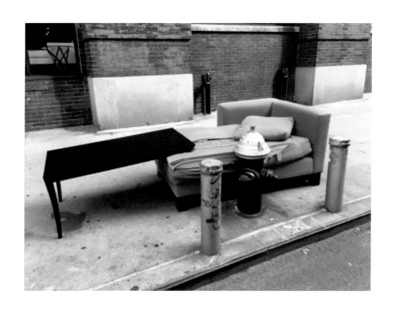

Psycho analysis.
Found by Amy Sedaris

Let's all pound caffeine
until we've transcended
weather!
Found by Amy Sedaris

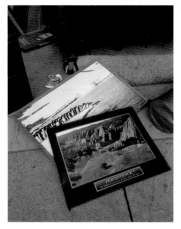

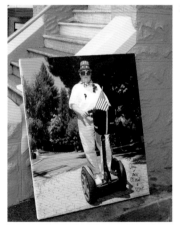

1
Creepy? What's creepy
about a bag of barbies?
Found by Gabby
in Bay Ridge,
Brooklyn, NY

2
Perfect book for a
fire hydrant.
Found in
Cambridge, MA

4
Somebody just lost their
motivation.
Found by Shane Hoffman
in Cambridge, MA

3
Uncle Sam rides a Segway.
Found by Ken in
San Francisco, CA

5
Happy 3rd Birthday, kid.
Found by Omer
in Herzliya, Israel

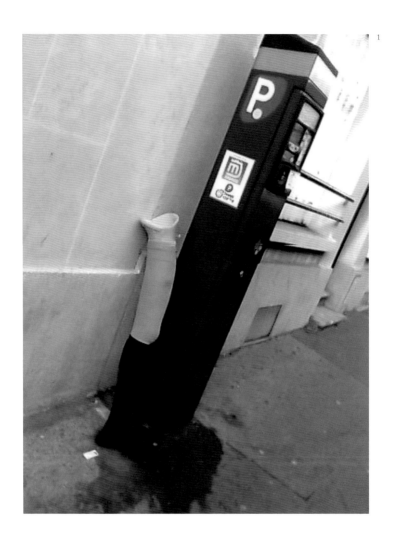

<table>
<tr><td align="center">1</td><td align="center">2</td></tr>
</table>

A Farewell to Legs.	Fallen glamour.
Found by Barbie Turik in	Found by Kathleen
Paris, France	Alcott in Brooklyn, NY

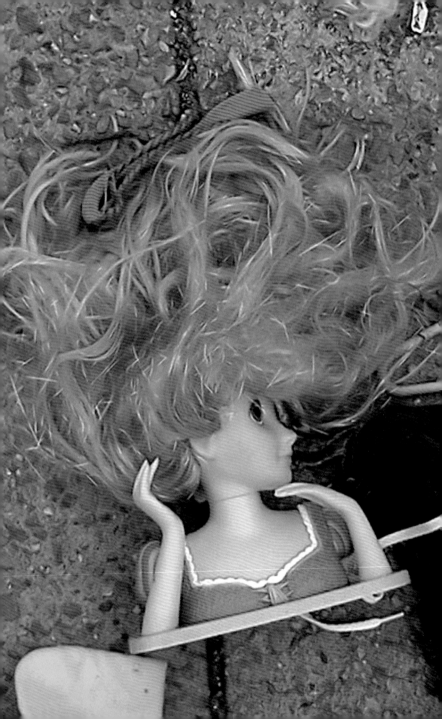

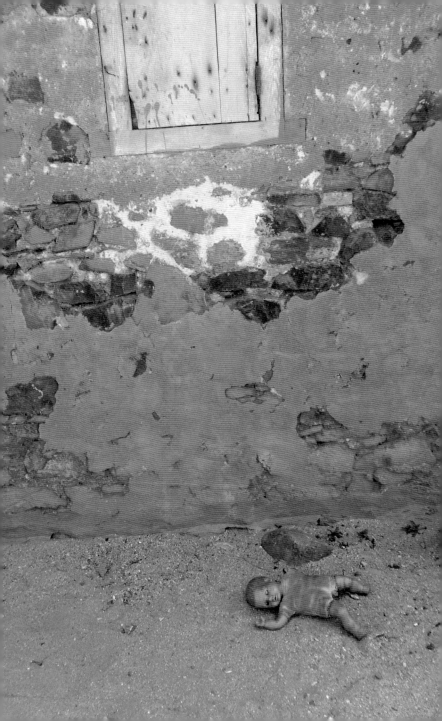

1
Cover photo for
Fodor's Senegal.
Found by
escapadesinafrica in
Dakar, Senegal

2
Never too young to start
break-dancing.
Found by Hannah in
Lavapiés, Madrid, Spain

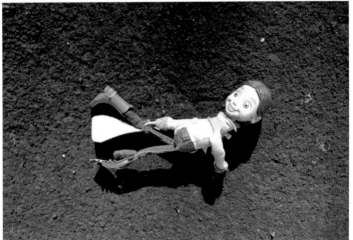

1
You should see the
other guy.
Found by ladybugjuice
in Portland, OR

2
When you think about
it, Toy Story would
make a good horror film.
Found by Eleanor

3
Pantless Garbage
Barbie®.
Found by Savannah

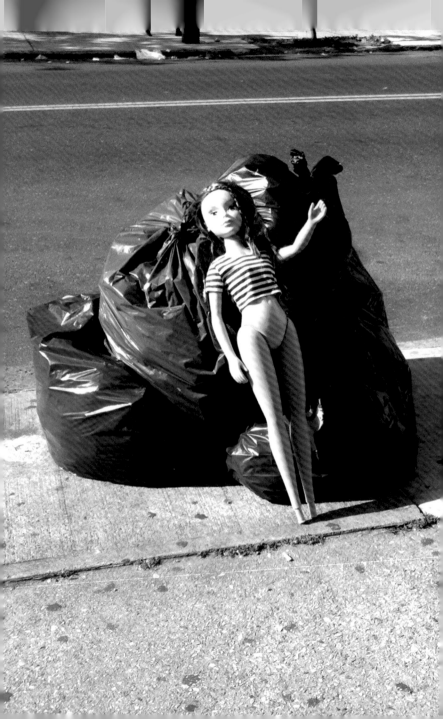

Maybe she's born with it.
Found by ojooro
in Seattle, WA

Open for groovy times.
Found by Omar Pringle
in Manhattan, NY

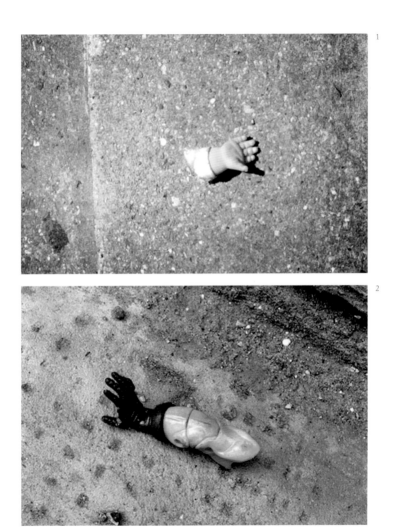

1
Sad and Alarmingly-
Realistic Baby Limbs
on the Street.
Found by
americanmadness

2
Superhero said to villain:
"Talk to the hand."
Found by Louise Desi in
Bermondsy, London

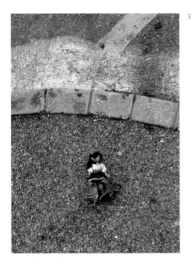

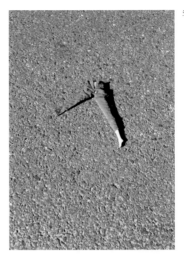

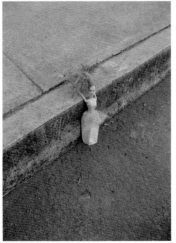

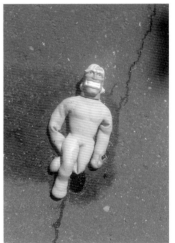

3
How eastern ladies do.
Found by Njapo & Buda
in Rijeka, Croatia

5
Barbie split.
Found by howironickylie
in North Adams, MA

4
Strung-Out-In-Mexico
Barbie®.
Found by elgatoalbino in
Mexico City

6
Grinning through the pain.
Found by youhavetheright-
toremainfabulous in
Bristol, UK

25

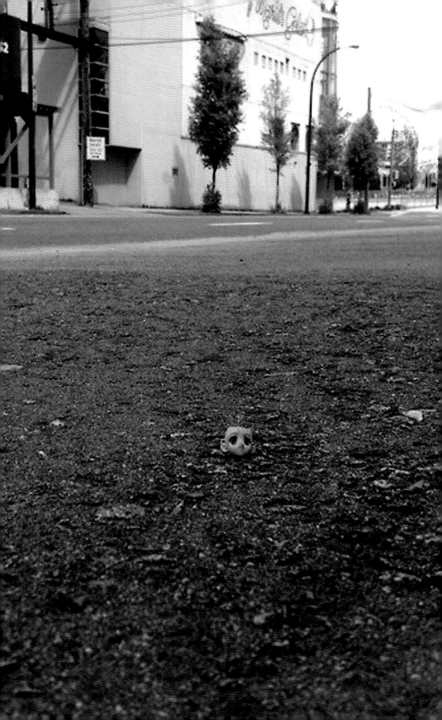

1
Rick Moranis has
done it again.
Found by rigovan
in Vancouver, Canada

2
'It was the one-armed
man!' —Dr. Richard
Kimble
Found by Jennifer
Slanker

3
He's all bark.
Found by lil-red-ban-
dana-on-a-stick in
Virginia Beach, VA

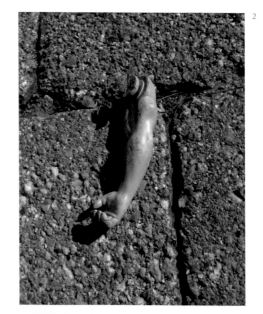

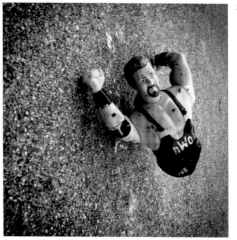

1
When Barbie left, Ken
hit rock bottom.
Found by pullmyfinger-
photography

2
Spider leg.
Found by Theresa
in New York, NY

3
Leg of Spidey.
Found by
fuckyouflapjacks in
London, UK

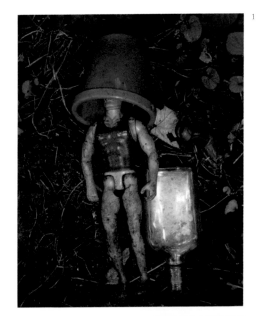

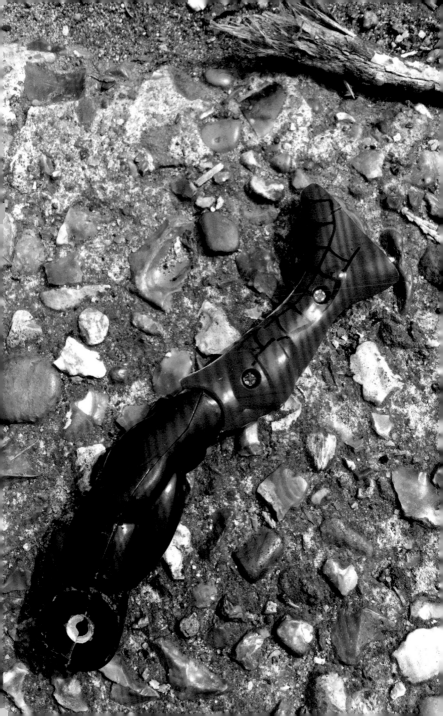

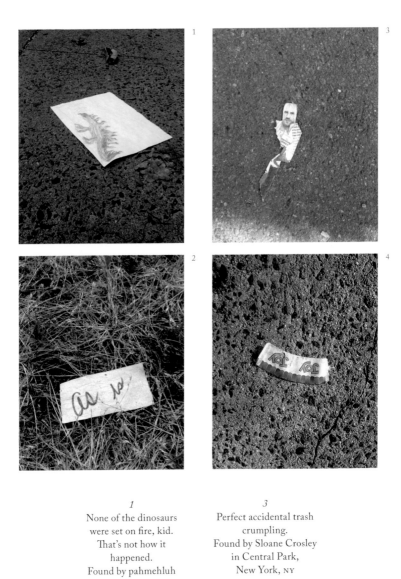

1
None of the dinosaurs
were set on fire, kid.
That's not how it
happened.
Found by pahmehluh

2
Metaphor for
environmentalism.
Found by queuedog

3
Perfect accidental trash
crumpling.
Found by Sloane Crosley
in Central Park,
New York, NY

4
Happiness is a choice.
Found by praisingfools
in Revere, MA

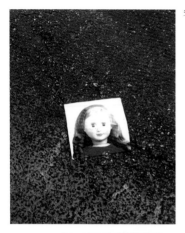

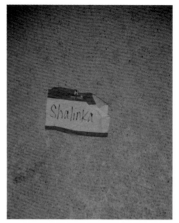

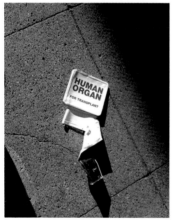

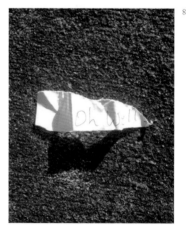

5
Welcome to the first
scene in your horror film.
Found by Stefanie Squier

7
Not anymore, it's not.
Found by Jessica
McLeod in West Palm
Beach, FL

6
Sally died on the
operating table due to a
take-out mix-up, but boy
did her doctor enjoy
that fajita!
Found by heyblockhead
in San Francisco, CA

8
Oh well.
Found by tellyjots

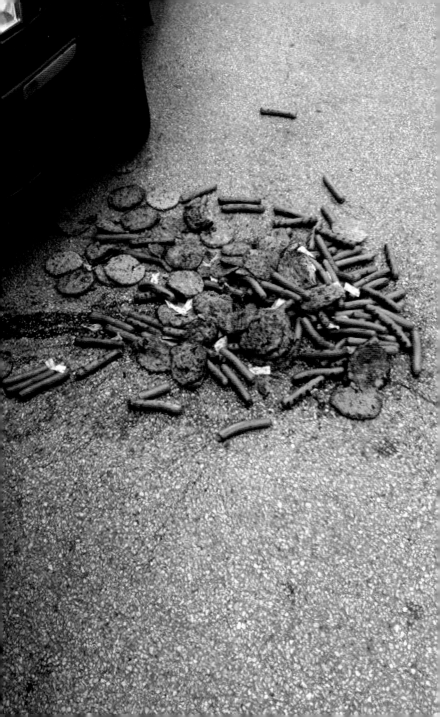

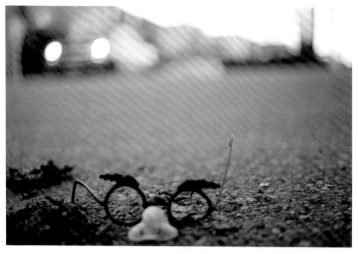

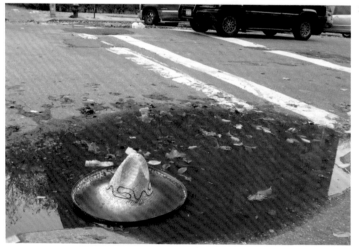

1	2	3
Carnivorous sadness.	Who's laughing now?	Wicked Witch
Found by Nicole Pritzker	Found by Simone	of the South.
in a parking lot	in Seattle, WA	Found by Ethan

<div align="center">

1
'I never get super special
ideas,' said Arthur.
Found by
secondhandhuman

2
Original cast of
The Beach.
Found by mississauggah

</div>

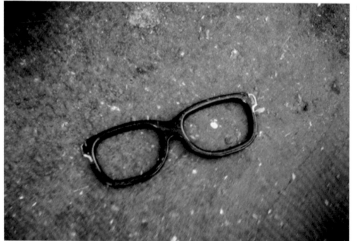

3
Flash card disaster.
Found by happytrailmix
in Missouri

4
Buddy Holly.
Found by Patrick John
Gioan in Nice, France

1	*2*	*3*
Sad Elmo Series #1: Pez. Found by Alexa in Williamsburg, Brooklyn, NY	The saddest air hockey paddle in the world. Found by Greg Amato in Newark, NJ	Optimus Past-his-Prime. Found by Jeannette

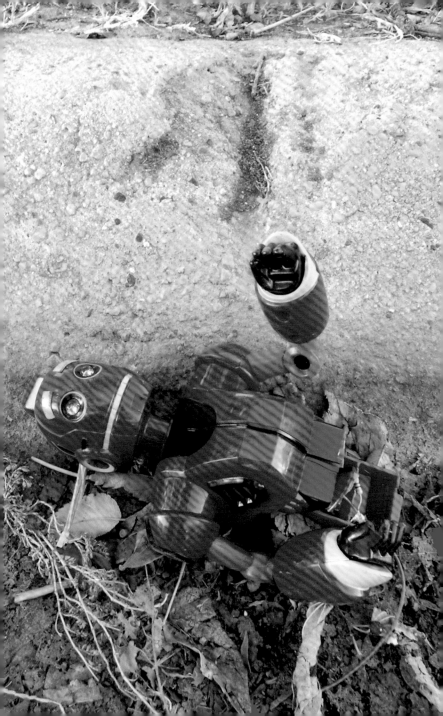

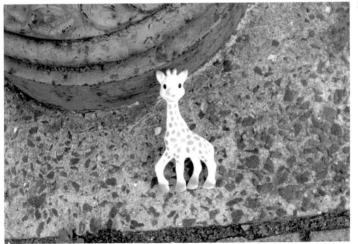

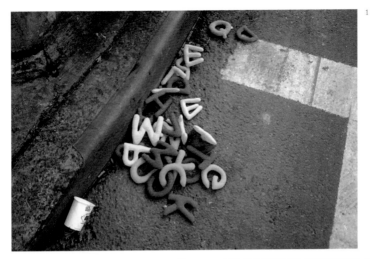

1
Gutter language.
Found by M.J.
in New York, NY

2
Looks for hope,
finds none.
Found by vreniwasaman
in New York, NY

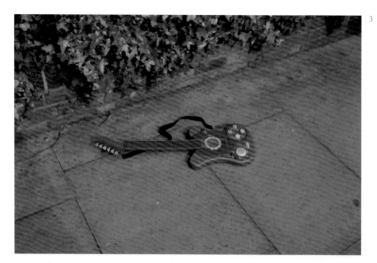

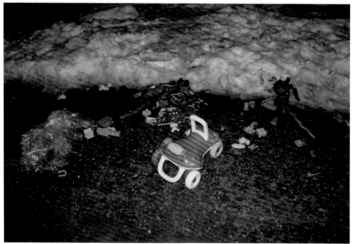

3
The guitar hero has
fallen.
Found by Frances Cherry
in Islington, London, UK

4
Toy Story: After Dark.
Found by
hypaethralsubterrestrial
in Brooklyn, NY

Miranda July

Last night was me and my husband's eighth wedding
anniversary. We had time to kill before our dinner reservation,
so we walked around the block, and passed this box. I've quickly
written "dead bird" on a paper bag before putting it in the trash
can. It's a courtesy to anyone who might be going through
your trash, like a homeless person. But I would never type up and
print out "Dead Rat". This seems like what you might do if you
were a secretary who'd been tasked with a dead rat. You'd want
to keep it professional, within the realm of your qualifications.
Keep the wild out, the death — I get it. Who I don't understand
is the person who saw the box on the street labeled "Dead Rat"
and opened it. Why do that? Why be so curious? Unless…
maybe they couldn't read or couldn't read English. That's
a bummer, to be the exact person who the message was written
for, but be unable to read it. Life is full of this kind of thing.
The good intentions of everyone involved just don't quite coalesce
into mutual understanding. My husband and I kneeled down to
get a look. The rat was still there, still dead.

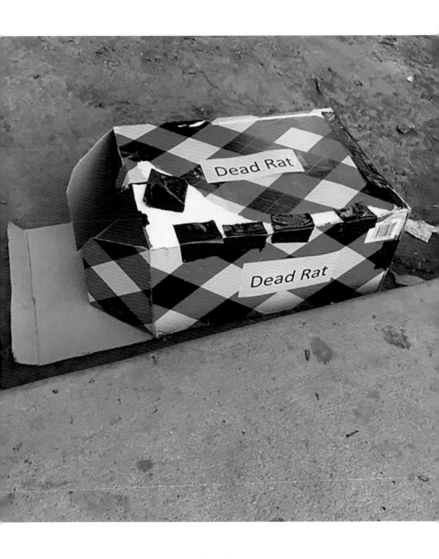

Dead Rat.
Found by Miranda July

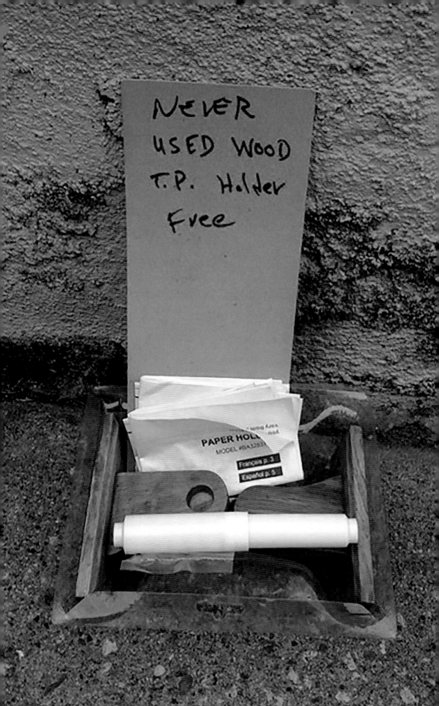

<div align="center">

1
Never used wood T.P.
holder. Free.
Found by Miranda July

2
Too lazy to teepee.
Found by rxbeckett

</div>

1
Dexter finale.
Found by Hanna W.

2
I'm an Ass Man.
Found by
Zoë Marshall-Rashid in
San Francisco, CA

3
Broken rainbow
umbrella lying on a
driveway.
Found by Greg Larson

1
Probably better this way.
Found by kcolbrolyt
in Clearwater Beach, FL

2
Let's all get up to
Canada one of these
days.
Found by marginalist in
Toronto, Canada

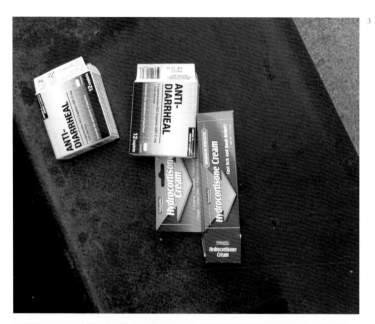

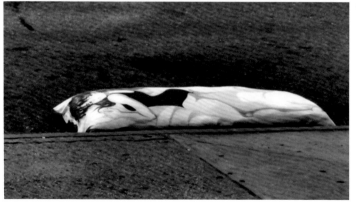

3
A bad day.
Found by Michael
Bloczynski

4
Just another mundane,
Anime-themed body
pillow lying in the gutter.
Found by dragonessence
in New York, NY

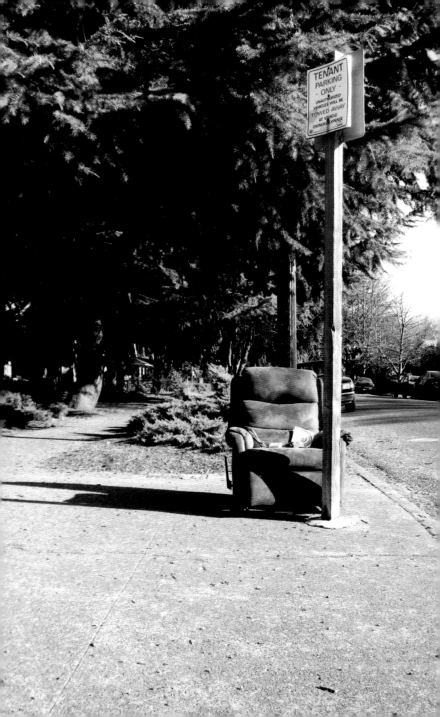

TENANT
PARKING
- ONLY -
UNAUTHORIZED
VEHICLES WILL BE
TOWED AWAY
AT VEHICLE
OWNER'S EXPENSE

1
No Sitting Anytime.
Found by Kara

2
A desk of one's own.
Found by davidhadar in
Tel Aviv, Israel

3
TempurPedic Rained-On
Soaking-Grey
Pavement-Posture
Pillow®.
Found by Jennifer Graves

1
Baby was a
talentless hack.
Found by Ryan Stirtz
in Oakland, CA

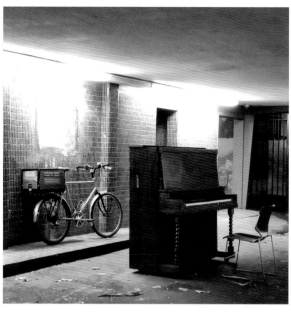

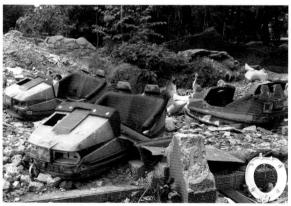

2
Still works.
Found by Colin in
Vancouver, Canada

3
Bumper car hate crime
in Bangladesh.
Found by DJ DiDonna
in Dhaka, Bangladesh

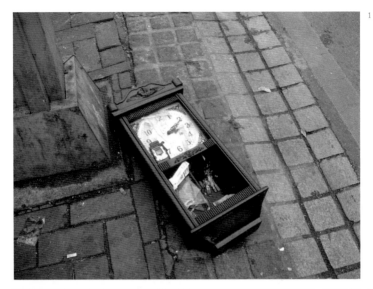

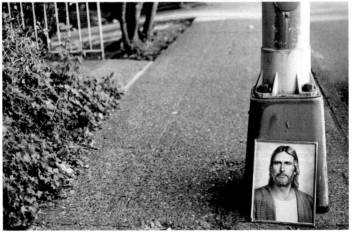

1	2	3
How to stop time.	Sad Jesus on the Street.	So far from the sea.
Found by reactionary in	Found by	Found by thesepics
Seoul, Korea	pennycollection	in Paris, France

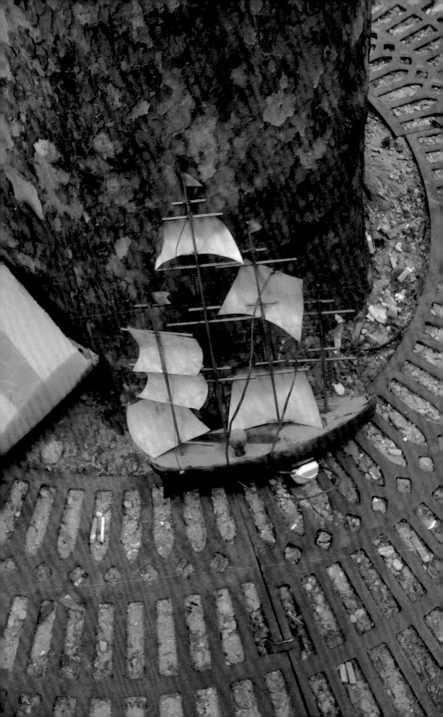

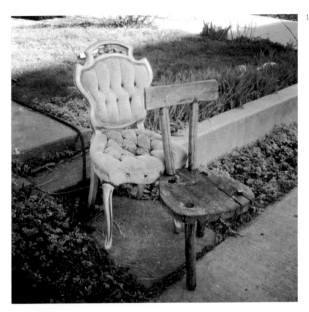

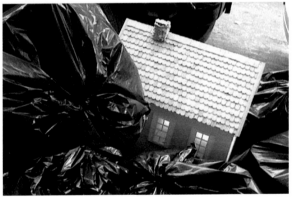

1
Lady and The Tramp.
Found by roundletters

2
Depressed housing
market.
Found by Sarah Ball on
the Upper East Side,
Manhattan, NY

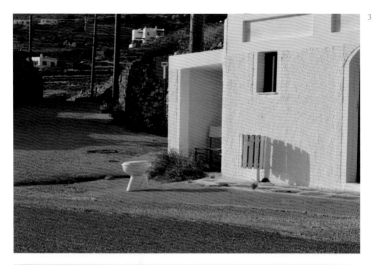

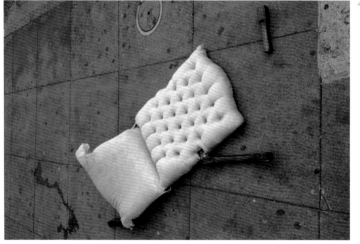

3
Ode to a Grecian Urn.
Found by nikfaf
on Tinos Island, Greece

4
I give up.
Found by Raphael
Schaad in the Mission
District, San Francisco,
CA

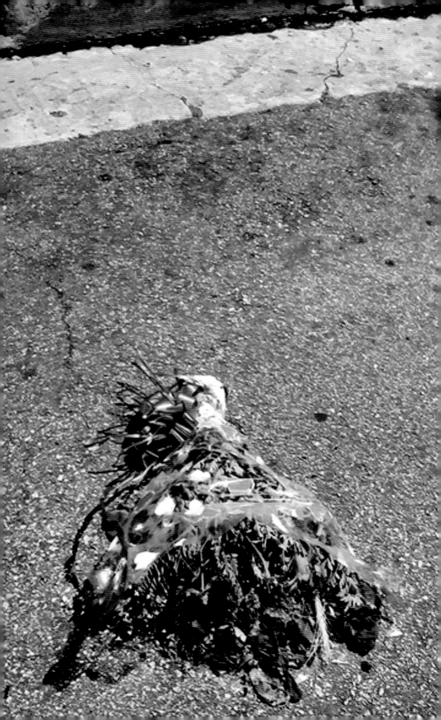

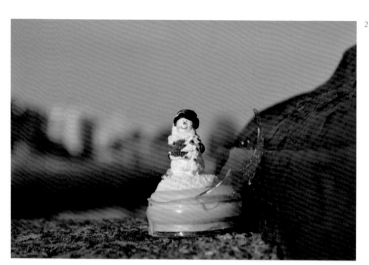

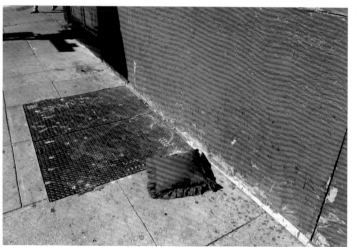

1
Unrequited.
Found by guidzaum

2
Frosty Unbound.
Found by suzwill in
Kilkenny, Ireland

3
Color-coordinated litter.
Found by Greg Larson
in San Francisco, CA

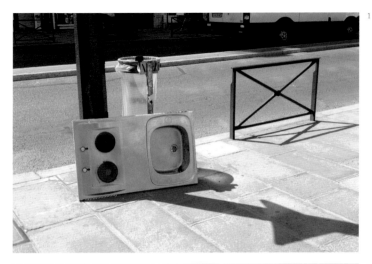

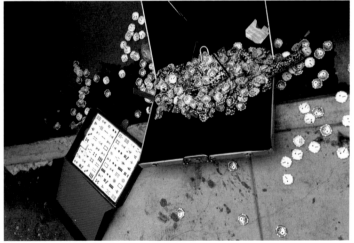

1	2
Everything including the	Game over.
kitchen sink.	Found by Tiffany
Found by Brittany Klaus	in Nolita, New York, NY
in Paris, France	

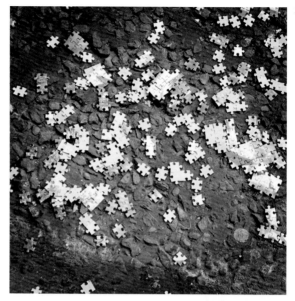

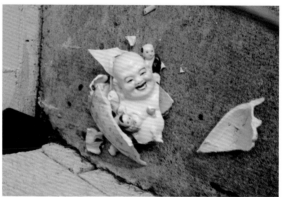

3
Puzzle pieces perform
elaborate flash mob.
Found by Uslan
in Hoxton, London, UK

4
Look within, thou art
the Buddha.
Found by Phil Brody in
Los Angeles, CA

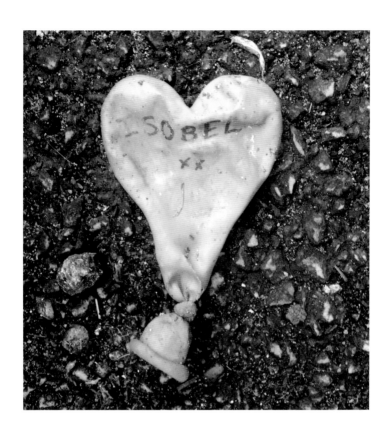

Isobel deflated.
Found by
armchaircommand in
Macclesfield, UK

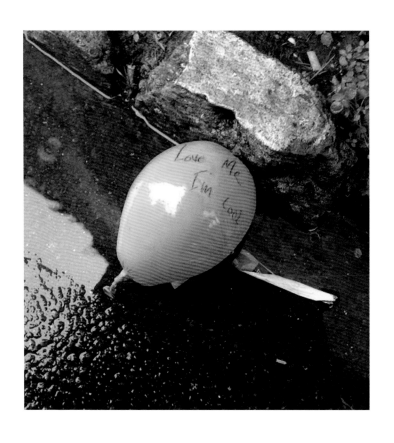

Half-deflated balloon in
a puddle with the words
"Love Me I'm Cool"
in sharpie.
Found by Greg Larson

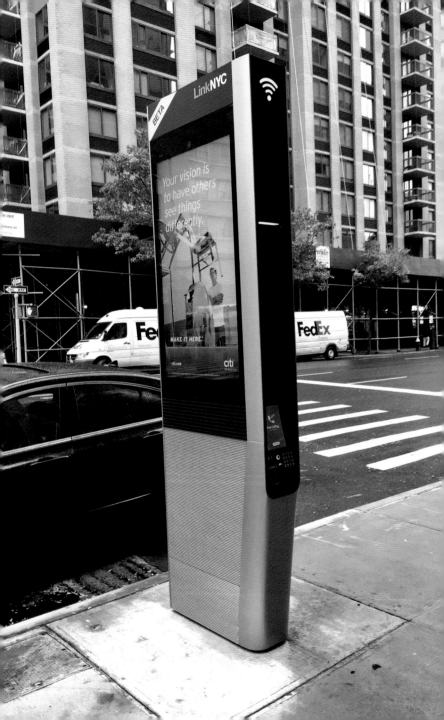

Jesse Eisenberg

I took a class in college called The Sociology of Shopping, which
should indicate that I did not have a very serious major. One
day, the professor, who was this young, rebellious woman (she
infiltrated Whole Foods by getting a job as a cashier in order
to document their unfair labor practices), asked the class, "Who
here wears headphones when they walk down the street?"
Everyone raised their hands. Everyone except me.

She continued: "When you wear headphones on the street,
you're cloistering yourself from an authentic sensory experience
with the urban landscape. And, apparently, Jesse and I are
the only ones who feel this way."

Yes! I thought. Only me and Professor Lowenstein—who we
were allowed to call Rachel! — understood how the Orwellian
corporate overlords were manipulating our brains.

The truth was, I just didn't own a pair of headphones. I wasn't
opposed to them on any political grounds — I probably
hadn't thought about headphones at all— but I did like being
part of Rachel's weekly Anti-establishment Club of Higher
Consciousness.

This was a decade ago, but I remember it clearly because, soon after this class, I quit the club and guiltily bought a pair of headphones. And they were just the beginning. I now read while walking down the street, I make phone calls (through head-phones), I listen to a dozen different podcasts (at 1.5 speed in order to fit them all in). And I feel guilty for all of this because I know it's just further alienating me from having real interactions with the outside world.

So when I see these LinkNYC machines scattered about our city streets, I feel sad on behalf of Rachel and I mourn for the civic-minded person she assumed I was.

At first, these machines seemed like a good way to provide Internet access to those who couldn't afford it. But then, the web-browsing feature was disabled because they were being used to watch porn and, in some cases, masturbate on the street.

Now, they're just these huge, brightly-lit Citibank ads in the middle of the sidewalk, a replacement for the antiquated but charming New York City phone booths.

I know it's trite and bitter to lament the loss of previous technologies, as though we don't benefit in a million different ways from podcasts and headphones and having the Internet everywhere, but these ironically named LinkNYC things seem like a kind of clunky solution.

And, at least with phone booths, people could masturbate in private.

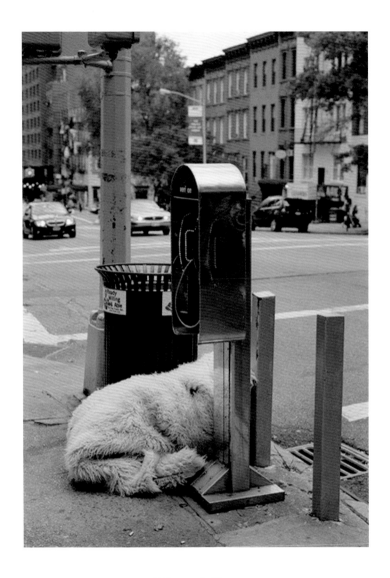

Falkor on the Upper
East Side.
Found by Alex Krauss in
New York, NY

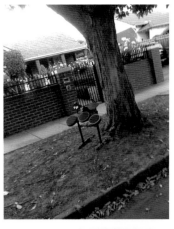

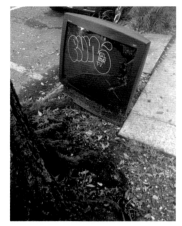

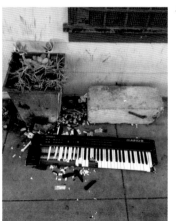

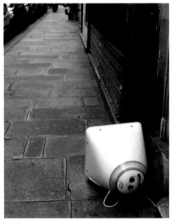

1
The rock fantasy ends.
Found by harmangood in
Melbourne, Australia

2
Le Mac tristesse.
Found by Paola in Paris

3
Done and done.
Found by les-images-de-
la-rue

4
Don't worry, I have an
app for that.
Found by Jordan Bass in
San Francisco, CA

5
Somebody got an iPad.
Found by anonymous

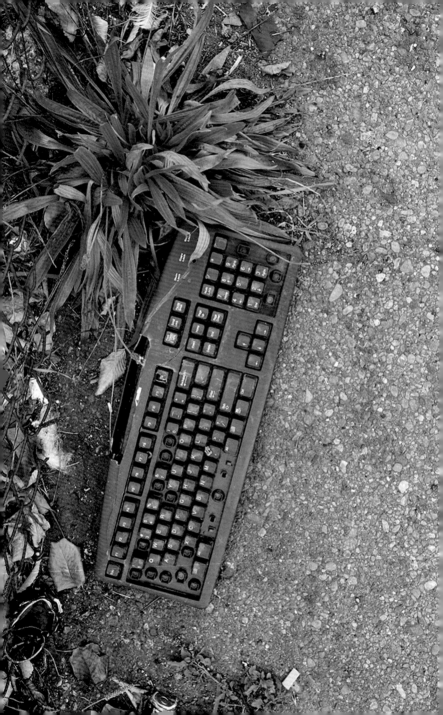

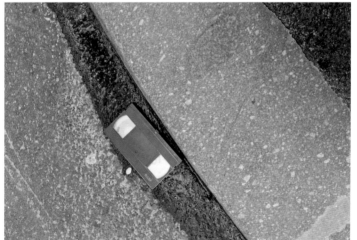

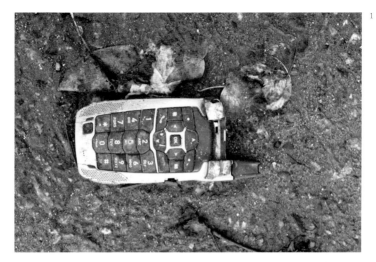

1
It's genocide season for
all dumb-phones.
Found by Greg Amato in
Newark, NJ

2
Le VHS.
Found by Pictours Paris
in Paris, France

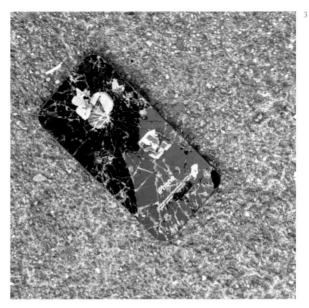

3
You crushed my heart,
you crushed my phone.
Found by beesandtrees

4
So that's where you've
been hiding.
Found by Anja Maatjes
in Rotterdam,
the Netherlands

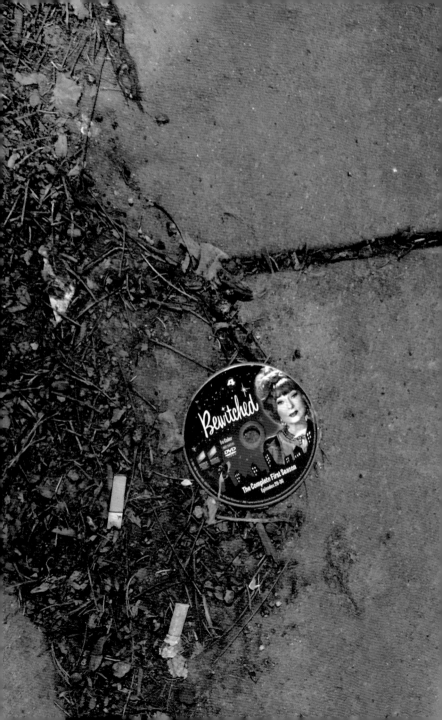

1
No one appreciates the
classics anymore.
Found by Mary Z. in
St. Louis Park, MN

2
Wild Wild
Upper West Side.
Found by Caroline
in New York, NY

4
Barbie Rapunzel.
Found by I'm Stuffed
With It

3
Started from the bottom.
Found by Catherine
Charbonneau in Albany, NY

5
RIP.
Found by phizeroth

Lin–Manuel Miranda

This is an abandoned apple in the men's room at a Mexican restaurant on the Upper West Side. I immediately pictured a Snow White/Godfather mash-up wherein the witch had this poisoned apple taped to the back of the toilet, but couldn't go through with it. So she sits down with Snow White (and the police chief??) and finishes her dinner instead.

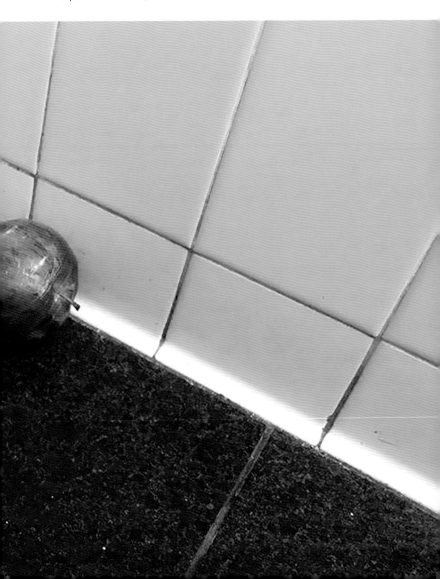

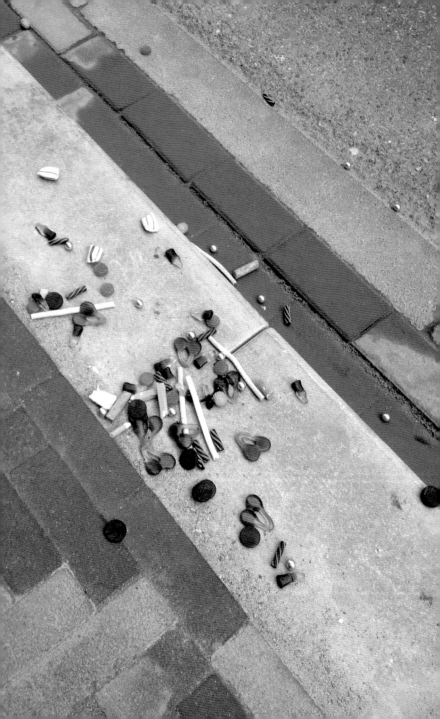

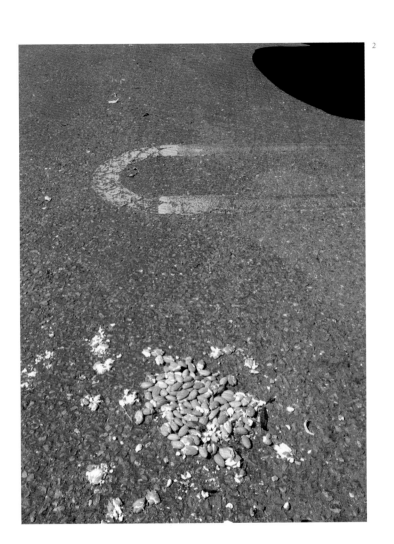

1
Somewhere there's a
really sad Dutch kid.
Found by
anjaelisabethhhh
in Amsterdam

2
They weren't organic.
Found by
imtextingyoufromhere
in Mill Valley, CA

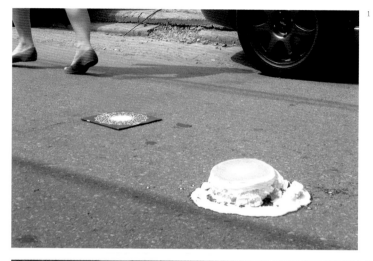

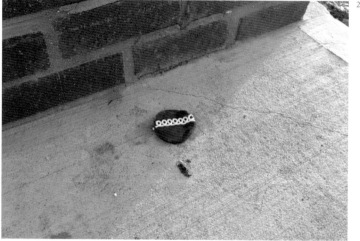

Happy birthday to
the ground!
Found by Andy Arnold
in Seoul, South Korea

2
Masochistic cupcake
eater abandons best part.
Found by 29160

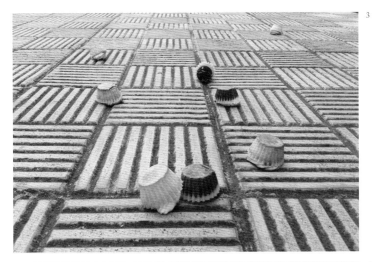

3
Suicidal cupcakes
can't take another
election year.
Found by Sandy Hugill
in Washington, DC

4
Oh, cool. Law & Order
makes cakes now.
Found by Nick Stern in
Manhattan, NY

1
Not melting — crying.
Found by Paige
on campus at
Swarthmore College, PA

2
My cup turnneth over.
Found by Sloane Crosley
in Chelsea, New York,
NY

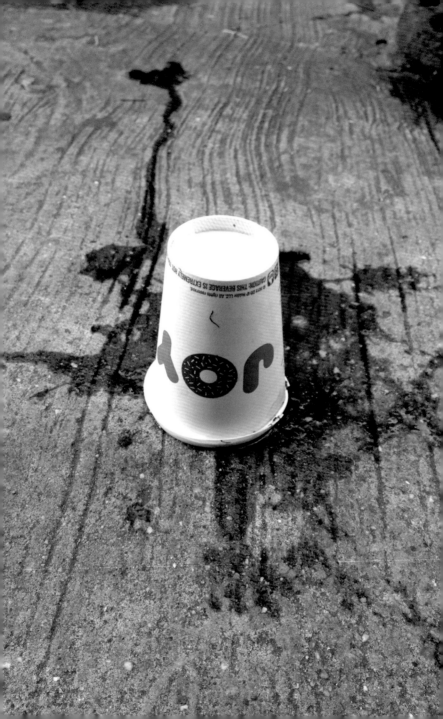

Ben Gibbard

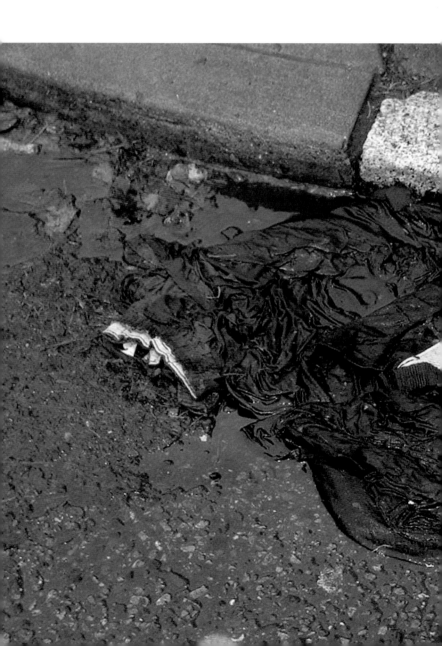

They had been drinking steadily since the afternoon and their jubilation had only progressed as they breached midnight at Kimberly's New Years Eve, Underwear-Only Dance Party.

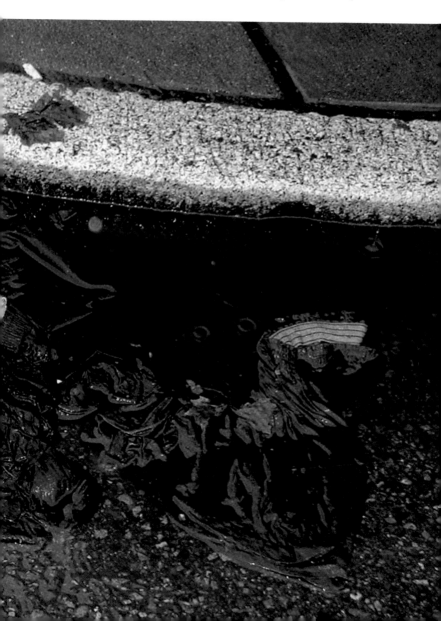

Such a good time was being had in fact that they failed to realize most of the other guests had vacated the premises not long after the customary champagne toasts and ceremonial kisses. Kimberly had been yawning conspicuously for 45 minutes until she abruptly silenced the stereo and gave them a definitive, *seriously you guys gotta get the fuck out*. It was just after 2am.

Having arrived to the party wearing the appropriate attire they exited the apartment as such; she in her black nightie, the three boys in their boxer shorts, all in smart yet stylish footwear. The dreariness of the early Northwest morning was palpable but no match for the copious amount of vodka coursing through their bloodstreams. Thankfully they weren't far from home; only 5 short blocks from Kim's place on Summit to their group house on Olive. As she could always be counted on to drunkenly suggest Late Night Stupid Shit, it was a shocker to no one when she turned to the boys with the challenge of, "Nekkid race back to tha housss. Lezz do thisss!"

Two of the boys accepted immediately while the other, for whom all the alcohol in the world couldn't overcome his prudishness, initially resisted. Only after the promise that they would divert their eyes from his nakedness did he join them. He discarded his boxers with the others just off the sidewalk and they lined up along a crack in the asphalt. She gave a hurried, "Ready...Set... GO!" and they were off...

Their lease expired the following June. Two of the boys got an apartment together in the Central District while the other moved into his girlfriend's place just down the street. She moved to Portland for work. They saw less and less of each other as the years progressed. Everybody won, everybody lost.

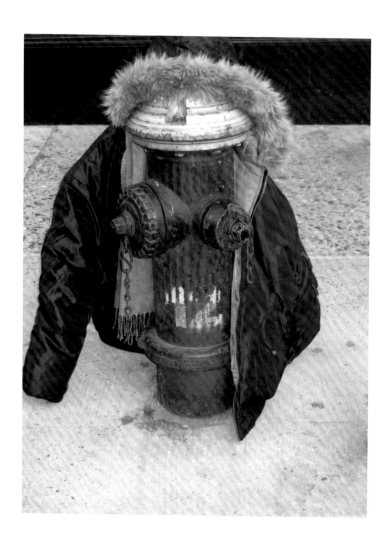

Prior Page
Found by Ben Gibbard

Above
Insulate and hydrate.
Found by Tony in Soho,
New York, NY

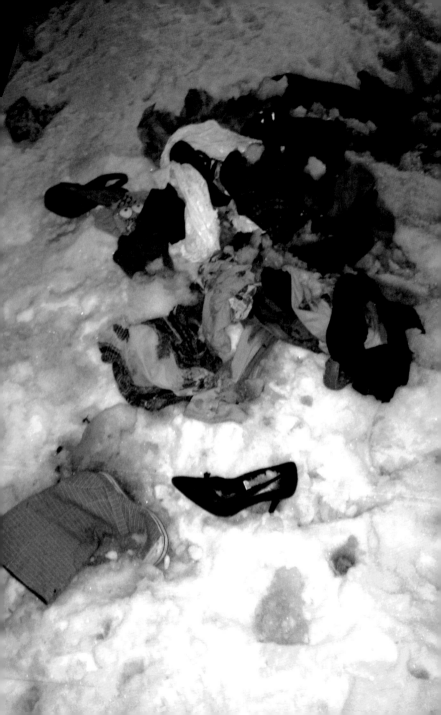

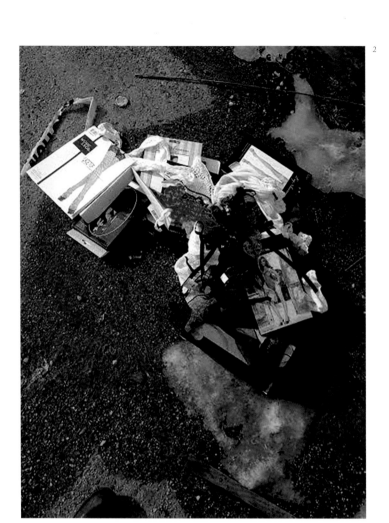

1
The Polar Vortex.
Found by Melissa W. in
South Boston, MA

2
Victoria is out of secrets.
Found by Evan in Sunset
Park, Brooklyn, NY

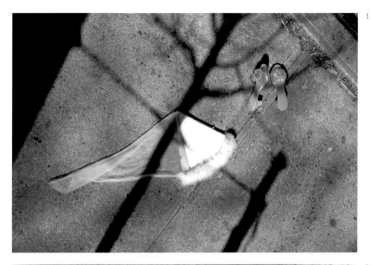

1
If everybody's special,
then nobody's special.
Found by gowanusinallo-
fus in Park Slope,
Brooklyn, NY

2
Somewhere, somehow
the one-legged
Barbie shops.
Found by
Meghan Buchanan in
New York, NY

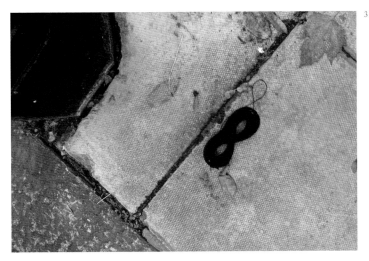

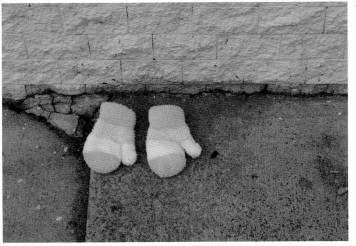

3
Phantom of the
Sidewalk.
Found by Marie-Louise
Desi in London, UK

4
California Mittens.
Found by paintedgaze in
Los Angeles, CA

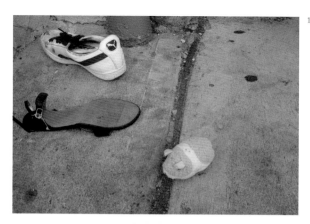

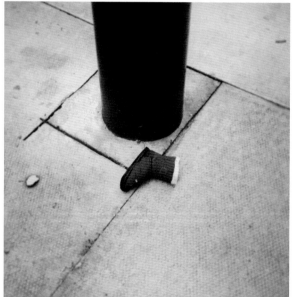

1	*2*	*3*
Puma preys on yellow mouse. Found by Rob Hill in Bushwick, New York, NY	Santa's little helper. Found by Caspar Thomas	Lost in the concrete jungle. Found by misscoleenmorris in Edinburgh, Scotland

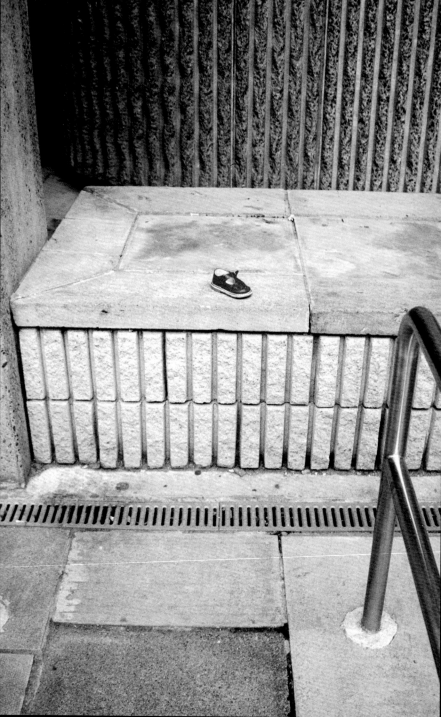

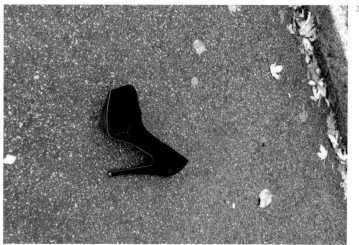

1
A sweater drenched in
the rain.
Found by Greg Larson
in San Francisco, CA

2
Helping an old street feel
sexy again.
Found by patrickmdunn

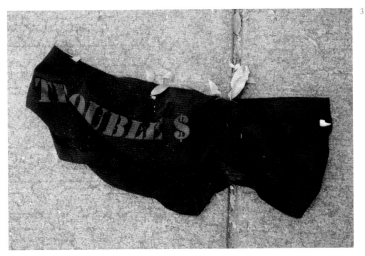

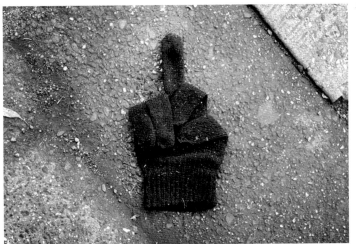

3

Found by chrisdpics

3
Trouble $.
Found by chrisdpics

4
G'day, mate.
Found by bitsadumpy in
Melbourne, Australia

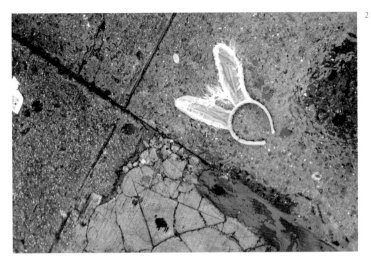

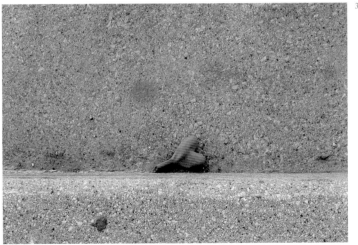

<table>
| *1* | *2* | *3* |
</table>

1	*2*	*3*
A latex Fuck You glove. Found by Andrew	Happy Easter. Found by Bomarr in New York, NY	You kicked me and my small deflated heart-balloon to the curb. Found by Yapchaian in Chicago, IL

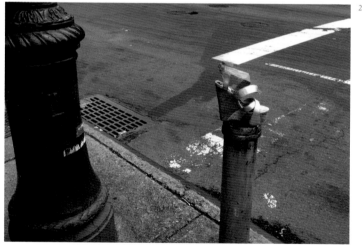

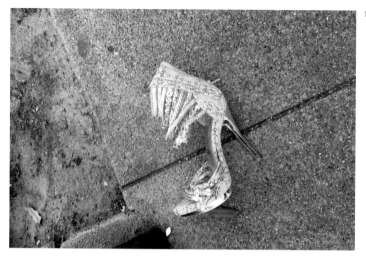

1
Someone fabulous lost
a shoe in Berkeley.
Found by Jeremy in
Berkeley, CA

2
Out of fashion.
Found by sbbezas on
the Upper West Side of
Manhattan, NY

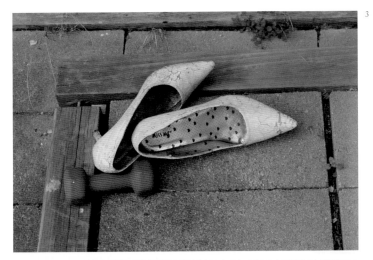

3
Sad Shoe Series #1:
The things that make a
woman a woman.
Found by Peter Meckel
in Ohio

4
Sad Shoe Series #2:
Too matchy-matchy?
Found by Michelle
in Vancouver,
British Columbia

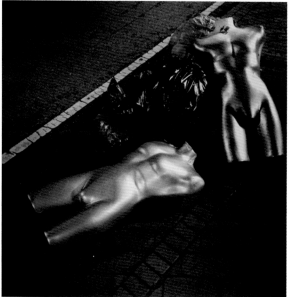

1	*2*	*3*
The Devil, and the Wicked Witch of the West, wear Prada. Found by Tron Javolta in Austin, TX	Liberace's trash. Found by casaamarilla in Bogota, Colombia	No straps, no love. Found by jimmytony

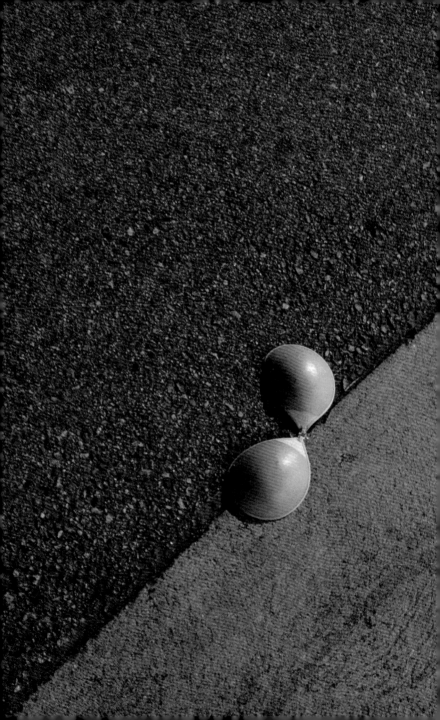

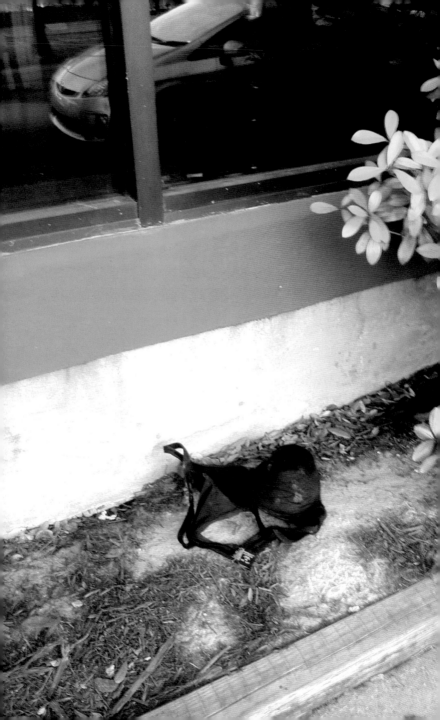

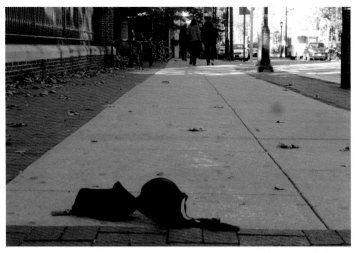

1
Scottsdale: The Topless
Senior Citizen Capital of
the World.
Found by chanbarausa in
Scottsdale, AZ

2
Leaves are falling, the
trees are topless.
Found by Laura Storck

3
Another freeing night in
The Big Easy.
Found by Dix Marie
outside of a hibachi
restaurant in
New Orleans, LA

1
Destiny's Child
breakup fight.
Found by flyovercountry
in the Warehouse
District in Minneapolis,
MN

2
Barbie's Sidewalk Salon.
Found by Greg Amato in
Newark, NJ

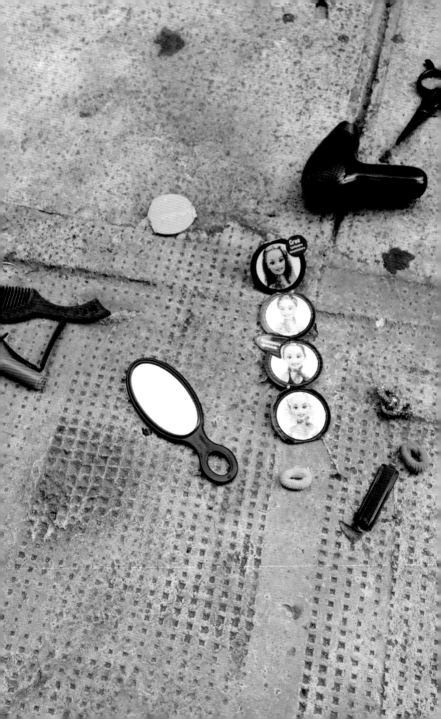

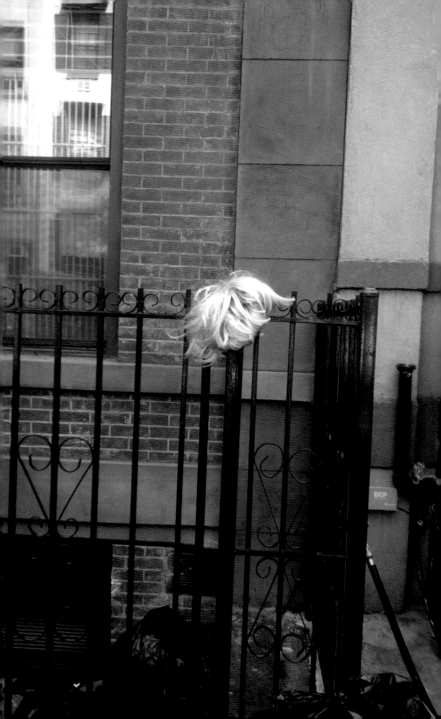

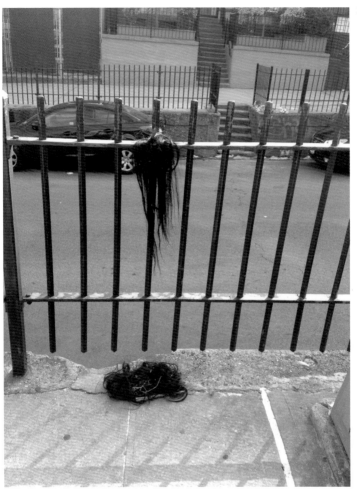

1
Blondes have more fun.
Found by mizqueenie

2
Yeti Unchained.
Found by Stephanie in
Brooklyn, NY

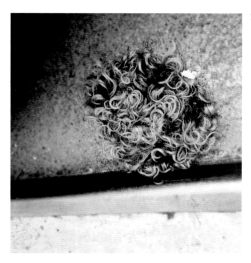

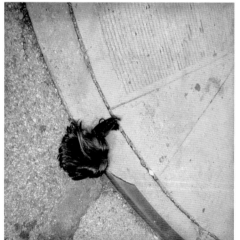

1
Missing wig.
Found by
whathappenedwas
in New York, NY

2
Blondes have more fun
but brunettes get
more lost.
Found by Adrienne in
Brooklyn Heights, NY

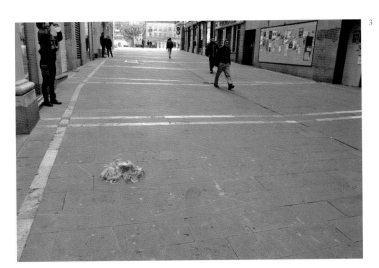

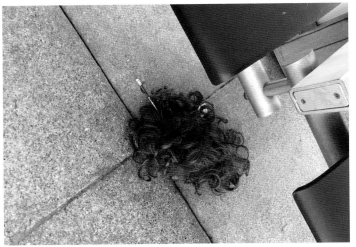

3
Running of the Blondes.
Found by bneller
in Pamplona, Spain

4
Wig with pencil still
in place.
Found by lahaham in
California

Michael Chabon

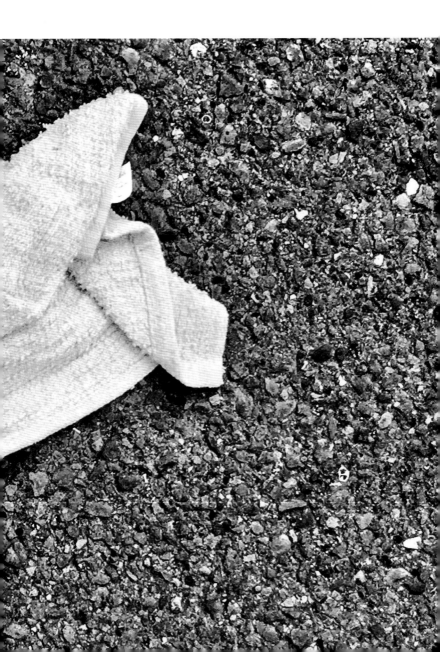

The cruel blow of finding himself thrown out into the middle of the street, he who was always so useful, so absorbent, now a mere hank of twisted fibers forgotten on the asphalt... And yet in the very depths of abjection— he finds her. Dark, enigmatic, ineradicable. Once he might have been tasked with mopping her up, absorbing her. Once he might have disdained the task as beneath him, icky, distasteful. Now, separated from her by a tiny yet unbridgeable gap, obliged to contemplate her hour after hour, he sees the integrity and tenacity and viscosity that until now he has always been too blind, too rigidly functional, to perceive. He is in love.

The sad part of the story is that he was gone the next morning, so somebody must have come along and tossed him into a bin. Or else, like, a bird took him and shredded him up for nesting material.

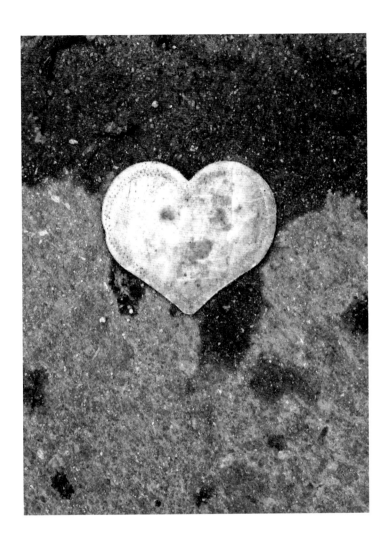

Above
Our love has been
sullied.
Found by ellalevyart

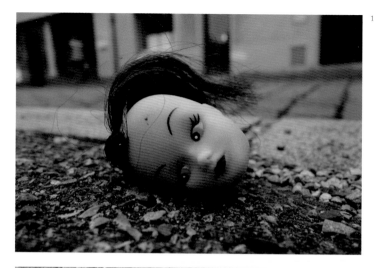

1
Bad head day.
Found by
michaelschreiner in
Augsburg, Germany

2
Got your nose.
Found by Izzy
in Pittsburgh, PA

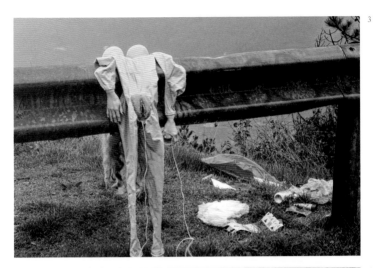

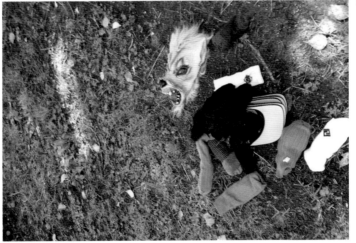

3
No more bunga bunga.
Found by ftosca
in Cinque Terra, Italy

4
The gentle werewolf who
hurts no one but
steals your socks and
baseball caps.
Found by redmillion in
Freiburg, Germany

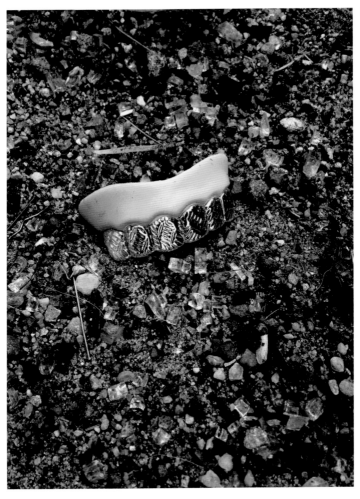

1
Halloween leftovers.
Found by Greg Larson
in Georgetown in
Washington, DC

2
Sad Grillz on the Street.
Found by hannahgaudite
at a 7-Eleven in South
Philadelphia

<div style="text-align:center">

1
All my friends are dead.
Found by on-account-of

2
Lock up your raisins,
people.
Found by Ellen
Margulies in Nashville,
TN

</div>

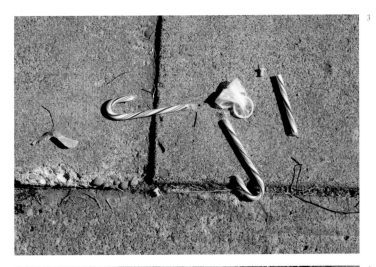

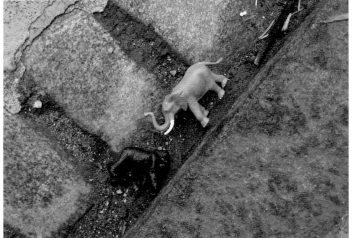

<div style="text-align:center">

3
Tacks, candy canes, and
a condom.
Found by Rachel Smith

4
Stalemate in the
urban jungle.
Found by K. Mackenzie
in Edinburgh, Scotland

</div>

1	2	3
Your crushed plastic salad container top is laughing at you. Found by Greg Larson in San Francisco, CA	Nerds. Found by Andrew Bangs in Brooklyn, NY	Mastermind. Found by Marina in Rome, Italy

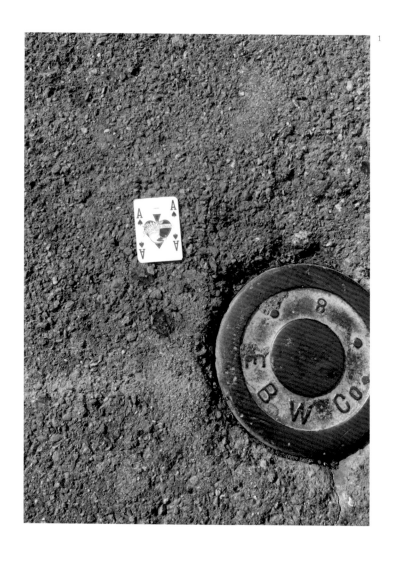

1
Ace near the hole.
Found by Jeremy
in Berkeley, CA

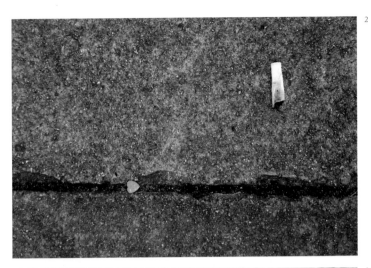

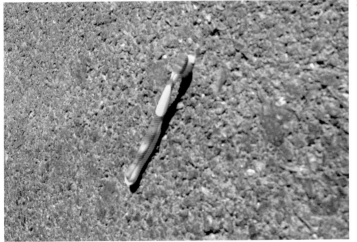

2
The heart and the stub.
Found by anonymous

3
It's fine.
Five second rule.
Found by ambienne in
the parking lot
of a Kohl's in Texas

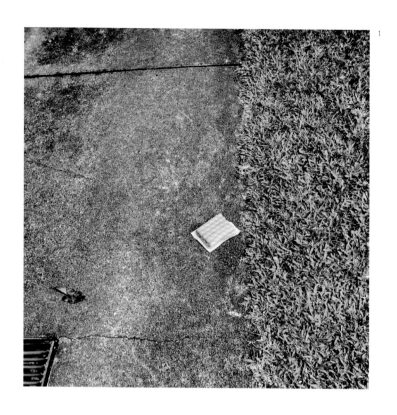

1
Street wieners.
Found by tellyjots

2
Wrong blog?
Found by Hoş geldiniz
in Eskişehir, Turkey

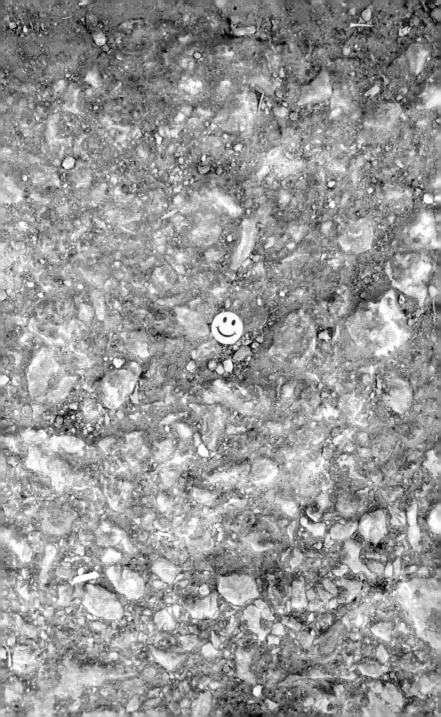

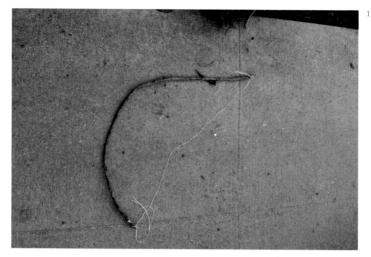

1	*2*
Didn't win Hunger Games.	No. More. Wire.
Found by Helen	Hangers.
Eastbrook in Los	Found by Sloane Crosley
Angeles, CA	in New York, NY

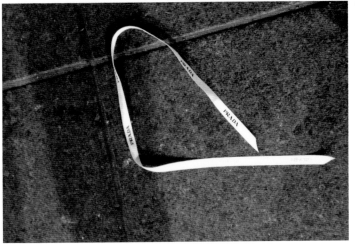

3
Fido?
Found by Thomas
Richardson

4
High fashion gets low.
Found by Sloane Crosley
in Midtown in
New York, NY

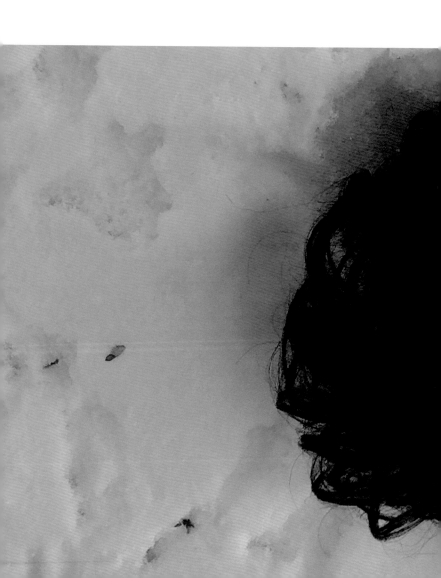

Todd Oldham

This is not the first time I have seen errant wiglets. Did it fall off unnoticed? Pulled off in an itchy scalp fit? Just inconsiderately discarded? Sometimes they look freshly styled so a recent loss is possible but what about the ones that appear in thawing snow like modest woolly mammoths? Was someone's day made better or worse by the discarding? All questions and this one fact, in all cases, my day is made better when I see one.

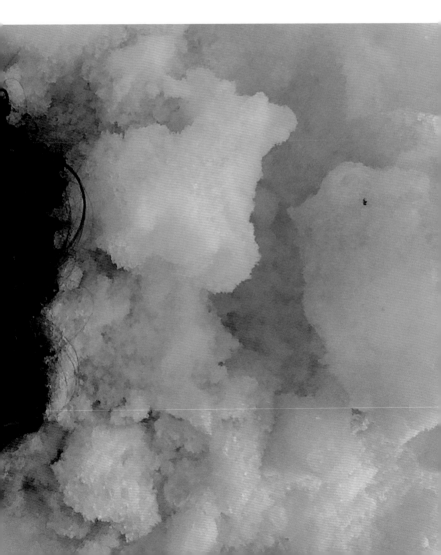

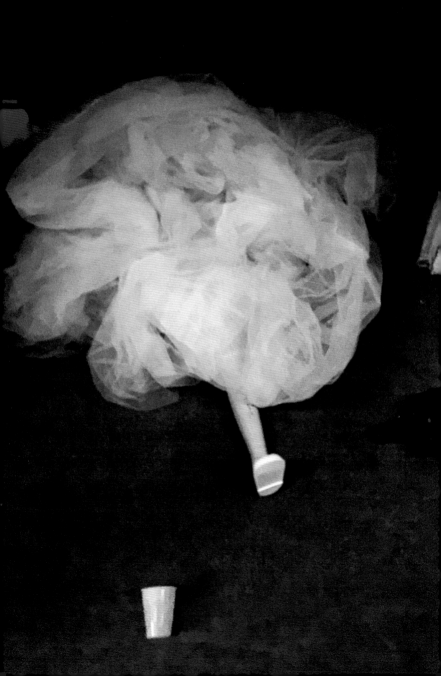

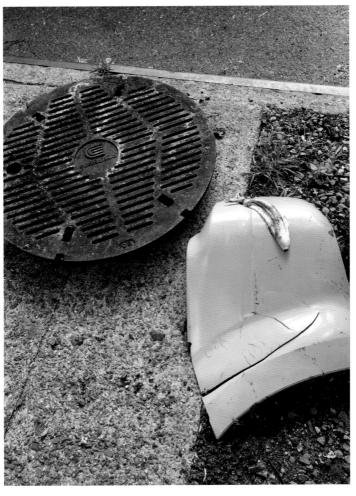

1
That scene in
Back to The Future.
Found by
Todd Oldham

2
Street still life.
Found by
Tony Longoria

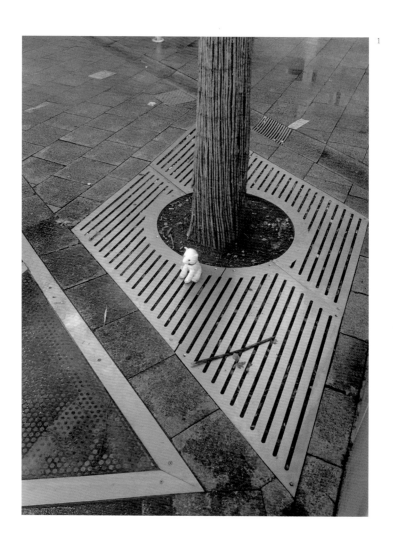

1
Waiting for mom to pick
me up after school.
Found by rmirolo

2
The well-dressed ele-
phant was no match for
the shallow
curbside puddle.
Found by Maureen in
Buffalo, NY

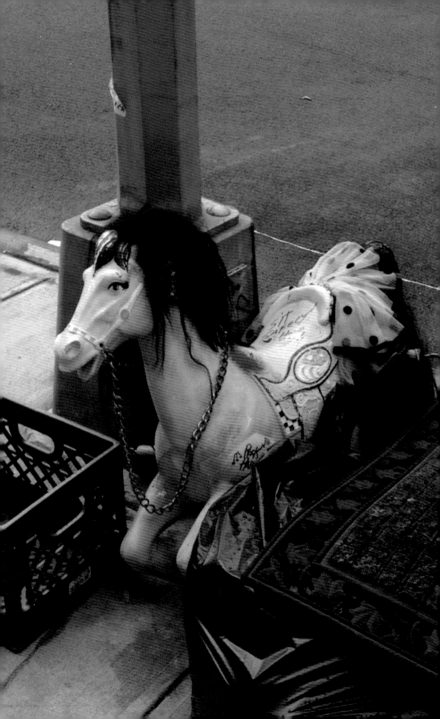

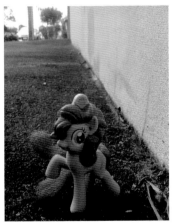

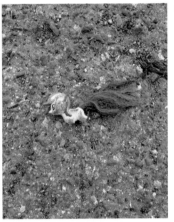

1
Ride's over,
everybody off.
Found by emlehan in
Brooklyn, NY

2
Deflated hoop dreams.
Found by Angelica in
San Francisco, CA

4
Keith Haring's bastard
child plays alone.
Found by doyouwantmore
in Toronto

3
Flirty even when
she's down.
Found by Julieanne
Campbell

5
Big trouble in
Rainbow City.
Found by Graham in San
Francisco, CA

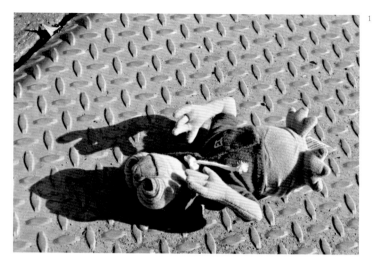

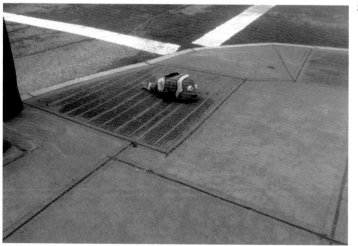

1
Phoned home, they
didn't answer.
Found by Inge-dus

2
Nemo: found.
Found by
Carly Weinberg

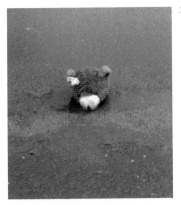

3

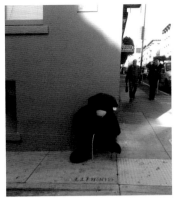

5

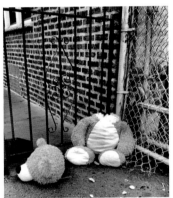

4

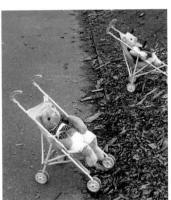

6

3
The lesser known fourth
little bear.
Found by Lander Bral in
Ghent, Belgium

5
Sometimes life is
unBEARable.
Found by Chris
in San Francisco, CA

4
Teddycide.
Found by George
Lacovara in Long Island
City, NY

6
Abandoned twins.
Found by
Rachel Antonoff

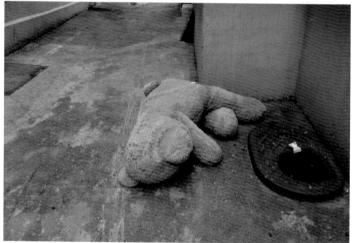

1
RIP Blitzen.
Found by Smithereen in
Carmel-by-the-Sea, CA

2
Death by soju.
Found by Jesper Sten-
berg in Sinchon, Seoul,
South Korea

3
Bad Unicorn.
Found by flyovercounty
in Soho, New York, NY

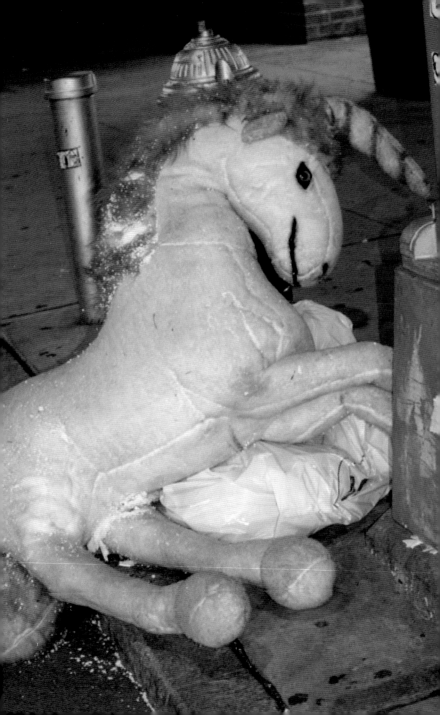

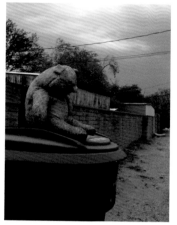

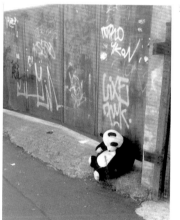

1
Just can't bear it
anymore.
Found by Andi Reynolds

2
Yeah I'm endangered,
but I'm also just having a
really bad day.
Found by Raul
in Bucharest, Romania

3
Slothbear guards trashcan
from impending storm.
Found by in-btw
in Tucson, AZ

4
Heads will roll, and they
will be adorable.
Found by Ulla in
Brooklyn, NY

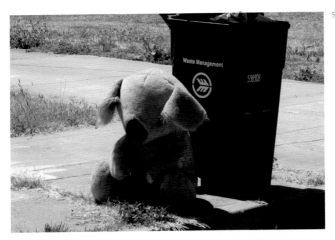

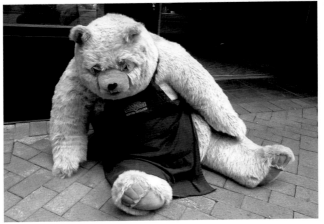

5
He knows where he's
going.
Found by Nate
in Hayward, CA

6
Depressed Teddybear
Series #9: Smoke Break.
Found by
Rick Gershman in
Denver, CO

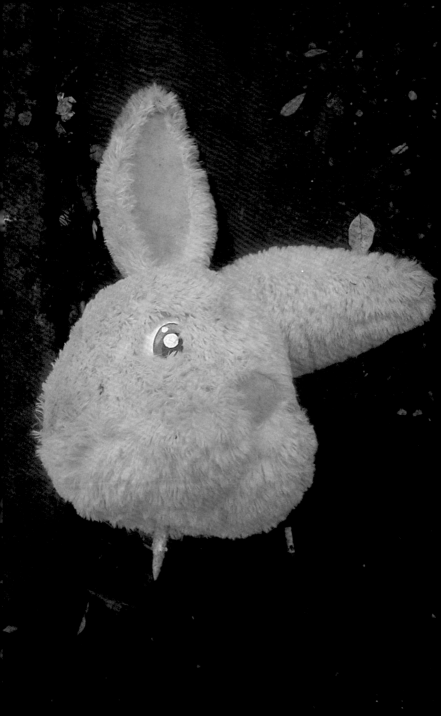

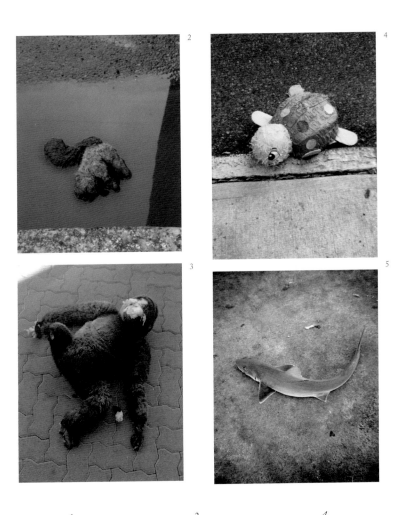

1
Easter in Bogotá.
Found by Julián Riveros
in Bogotá, Colombia

2
Stuffed squirrel now
stiff squirrel.
Found by Jason Jones in
Tribeca, NY

3
Monkey sans limbs, sans
face. Human uprising.
Found by Angela Petrel-
la in San Francisco, CA

4
Slow and steady doesn't
always win the race.
Found by Kate Flynn in
Clinton Hill, Brooklyn, NY

5
Jaws 5: Revenge on
Dry Land.
Found by 02211987 in
Bay Ridge, Brooklyn, NY

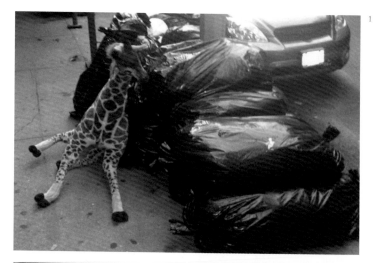

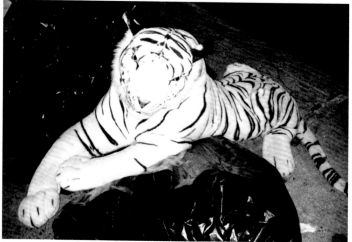

1
One man's trash is
another man's giraffe.
Found by Kenny

2
Endangered is a state
of mind.
Found by Alec Friedman
in New York, NY

3
The lion sleeps at night
but the white tiger
takes the day.
Found by angelgarcia-art
in Brooklyn, NY

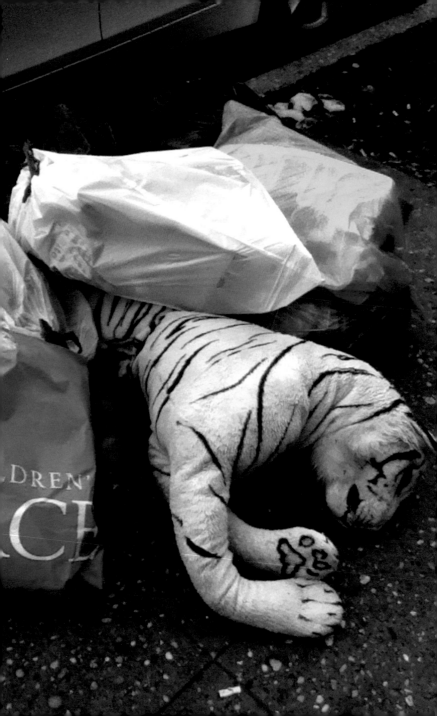

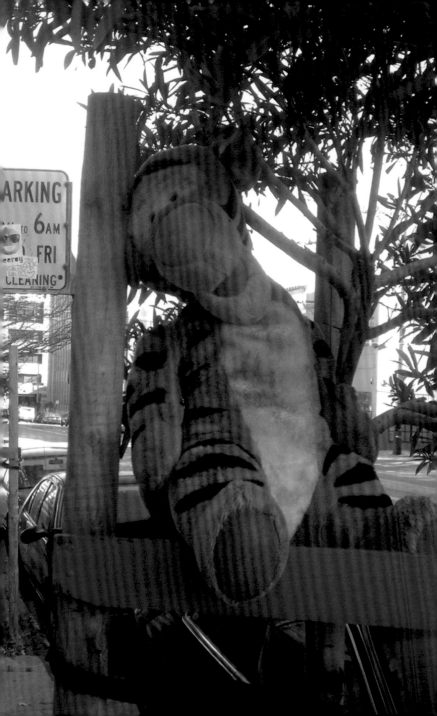

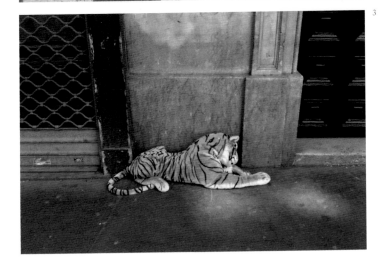

1	*2*	*3*
Bouncing was what Tiggers did best. Found by Ryan Lewis in San Francisco, CA	Head of Scooby. Found by virginiawooooolf in England	Le chat, elle est triste. Found by Lina Mariou in Paris, France

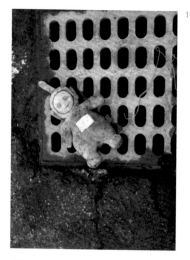

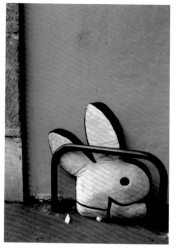

1
Teletubbicide.
Found by Meredith in
Brooklyn, NY

3
Playboy Bunny Unsexed.
Found by Lina Mariou
in Paris, France

2
KGB.
Found by desad in
Siberia, Russia

4
Lost puppy.
Found by anonymous

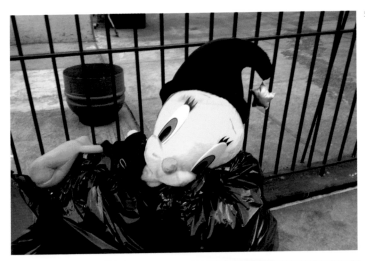

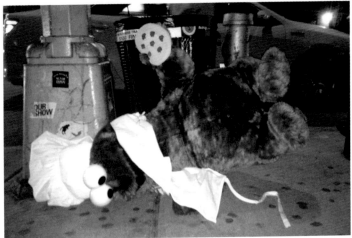

5
This is what happens
when you tweet too
much.
Found by Jordan Bowes
in Harlem, NY

6
You can't always get
what you want.
Found by Fran
Waldmann in New
York, NY

<table>
<tr><td>1</td><td>2</td><td>3</td></tr>
</table>

1	*2*	*3*
I can see your soul. Found by itakepictures-sometimesny	Owl you need is magic. Found by Nicola Barrett in London	No, really, you go inside. I'll stay out here and watch the meter. Found by Isaac Fitzgerald in San Francisco, CA

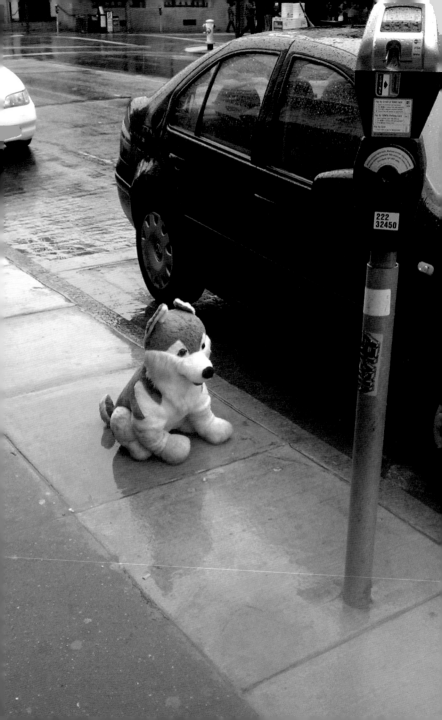

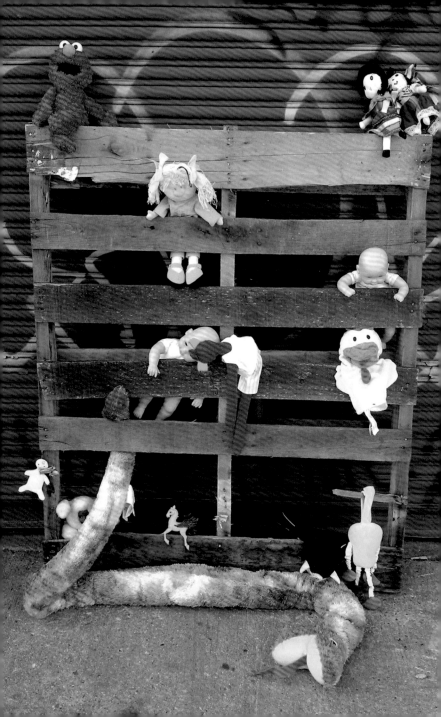

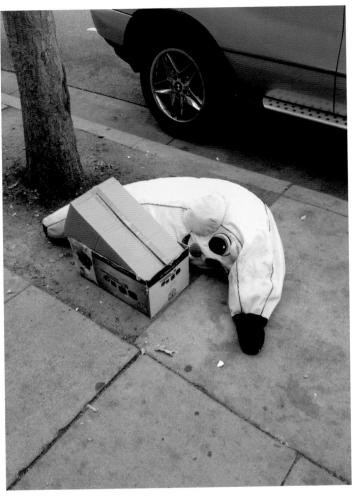

1
Sad Elmo Series #6: Me
& My Friends.
Found by Carlee Briglia
in Bushwick, Brooklyn,
NY

2
I feel like you're not
listening to me.
Found by
lostangelesstreetart in
West Hollywood, CA

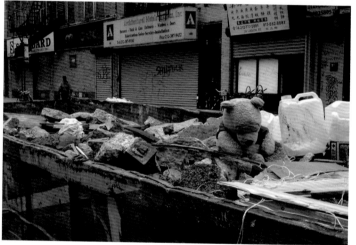

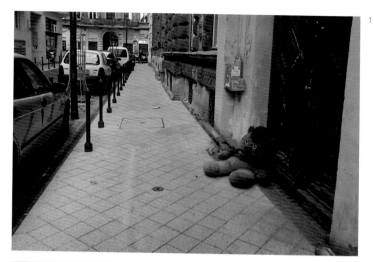

1	*2*	*3*
Somewhere in Europe, Teddy thinks of his fallen brothers. Found by lonelyeconomist	Depressed Teddybear Series: #1. Found by Rob Van Valen in Chinatown, New York, NY	Eeyore, strung out in the Tenderloin. Found by Marcin Wichary in the Tenderloin District, San Francisco, CA

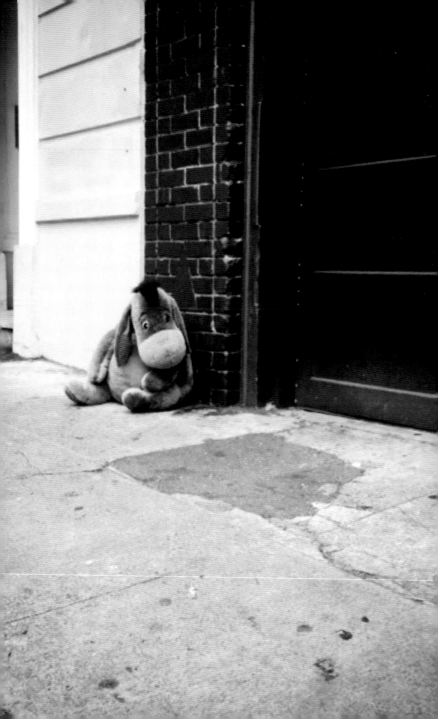

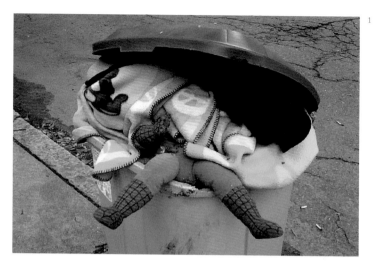

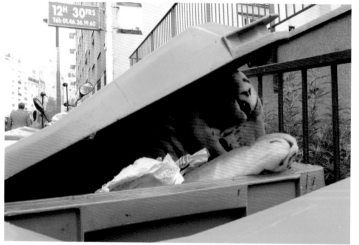

<div style="text-align:center">

1
With great power comes
great recyclability.
Found by Brad Searles in
Allston, MA

2
Zut! Le Tigre!
Found by lepublicnme in
Paris, France

</div>

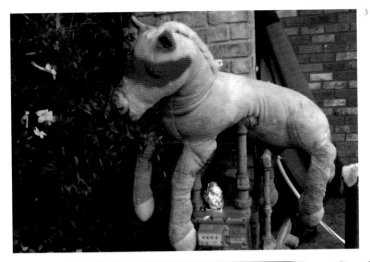

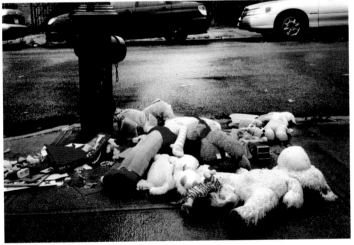

3
Pink Pony Bandito.
Found by Brittany Klaus
in Silver Lake, Los
Angeles, CA

4
Stuffed Animalcide.
Found by Olga Desh-
chenko in Sheepshead
Bay, Brooklyn, NY

Salman Rushdie

Friendly fascism.
Found by
Salman Rushdie

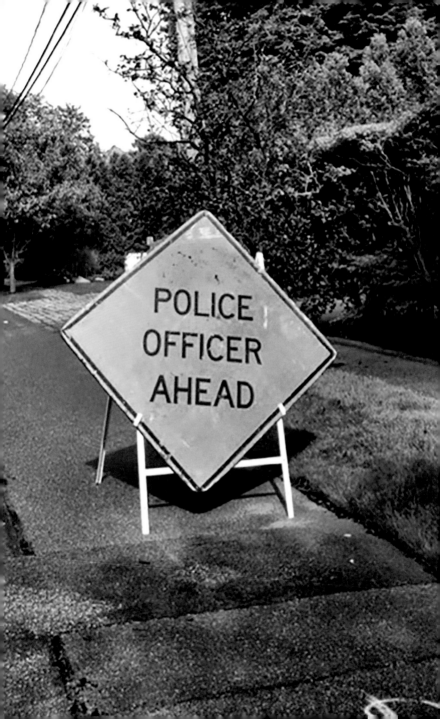

Thank You

Sloane Crosley and Greg Larson would like to thank

Todd Oldham.
Todd, we couldn't even get through the "first and foremost" here, we just had to type your name as fast as possible. Thank you for your dedication, vision, commitment and general joviality when it came to this book. It would not exist without you. We would also like to thank Karin Kunori, Nora MacLeod, Greg Kozatek, Joseph Kaplan and Eve (for the licks). And to Steve Crist and everyone at AMMO books. We are longtime listeners, first time callers — big fans now proud to be published by you. Finally, to all our friends, old and new, near and far, familiar and strange...this book is not ours. It's yours. Thank you for the constant reminder that every inch of this planet represents the opportunity to make something happy out of something sad.

Todd Oldham Studio would like to thank

Sloane Crosley & Greg Larson
Tony Longoria
Linda & Jack Oldham
Granny Jasper
Steve Crist
Gloria Fowler
Greg Kozatek
Nora MacLeod
Derya Altan
Joseph Escobar
Zoe Schlacter
Yusuke Watanabe
Michael Chabon
Jesse Eisenberg
Ben Gibbard
Miranda July
Lin-Manuel Miranda
Salman Rushdie
Amy Sedaris

Sloane Crosley
writes things, lives and works in New York City.

Greg Larson
lives in Washington, D.C., where he works in international development.

Todd Oldham
makes things, lives, and works in New York City.

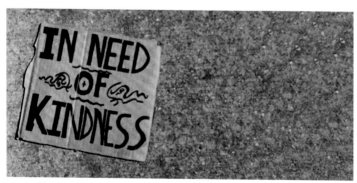

Above Take a number, Sign! Found by waterdaily
Right Just wanted to see an ocean sunset. Found by succedere-alci in South Africa

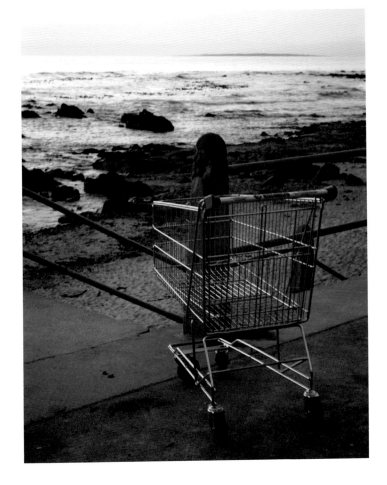

Design: Todd Oldham Studio
Karin Kunori and Joseph Kaplan

Front cover photo: Sloane Crosley
Back cover photo: Greg Larson

Publisher: AMMO Books
Printed in China

100% of all revenue received by AMMO
Books from the sale of this publication
will be donated to NAMI, the National
Alliance on Mental Illness. The authors
and creators of this book encourage you
to make personal contributions online
at www.nami.org.

ISBN: 978-1-62326-066-8

To enjoy the wonderful world of AMMO Books,
please visit ammobooks.com

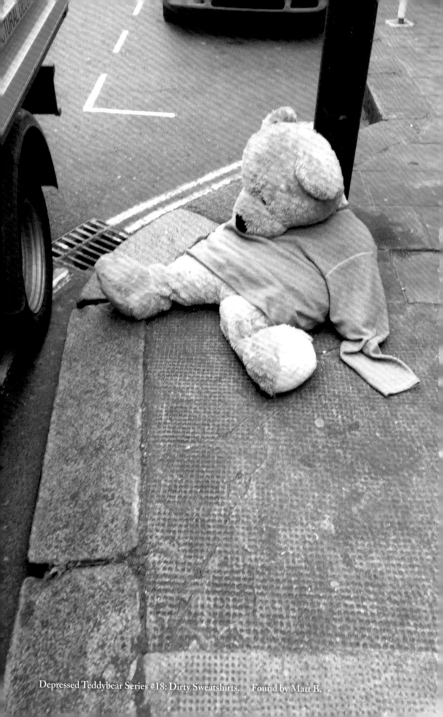

Depressed Teddybear Series #18: Dirty Sweatshirts. Found by Matt B.